# sines, tangents and cycles 2

drawn by: Michael Schaefer
*of*
*Ink on Paper Arts in Oregon*

Other work as well as prints
available for purchase via:
FB: Iopa Inor
Imgur: IoPA inOR

copyright: 2016 by Amazon/CreateSpace publishing

All rights reserved.
No part of this book may be reproduced or copied without written permission of the author.

**ISBN-13:**
978-1537285269

**ISBN-10:**
1537285262

For Bernie Sanders.

Thank you.

Clearly, an honest system is up to us.

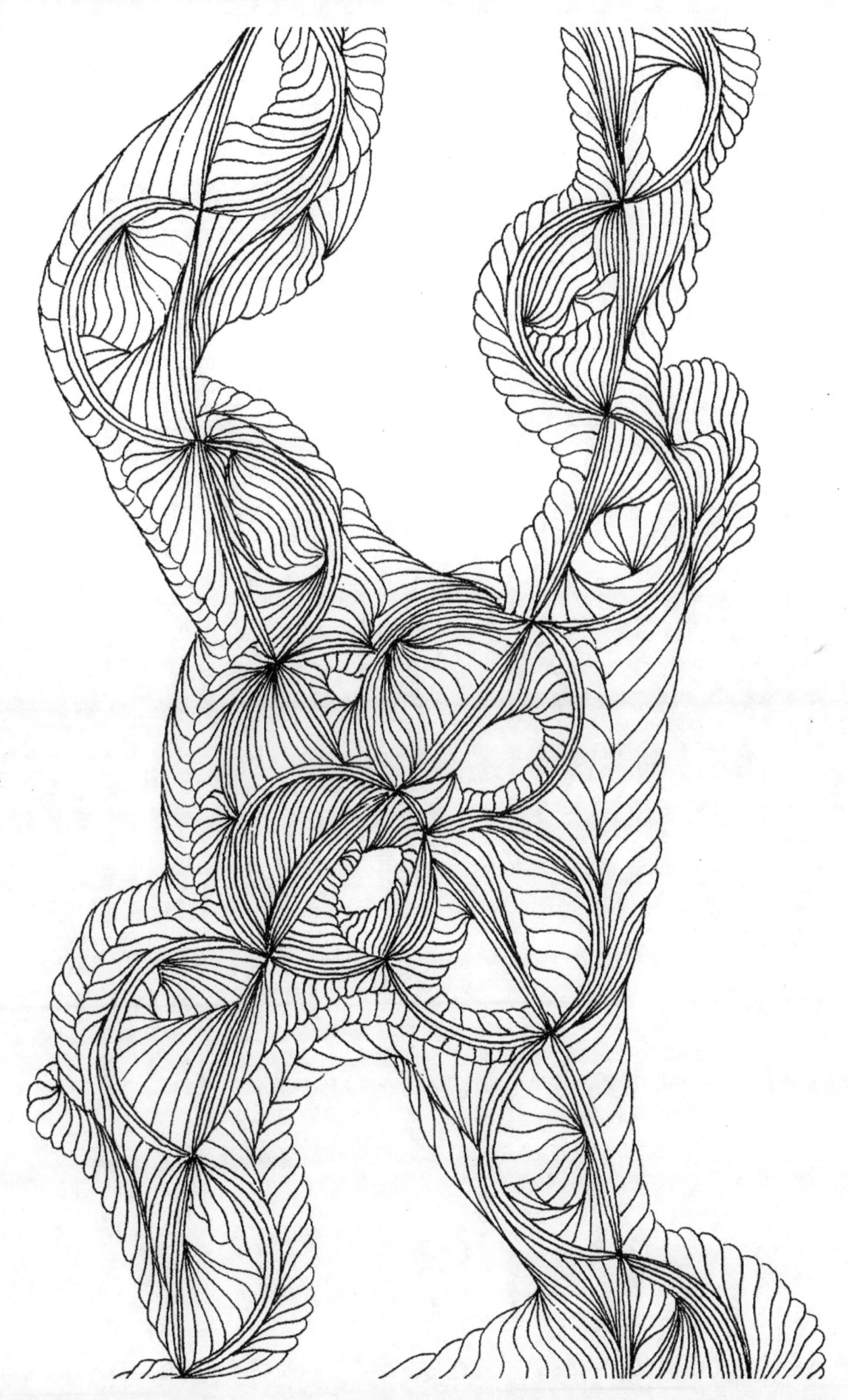

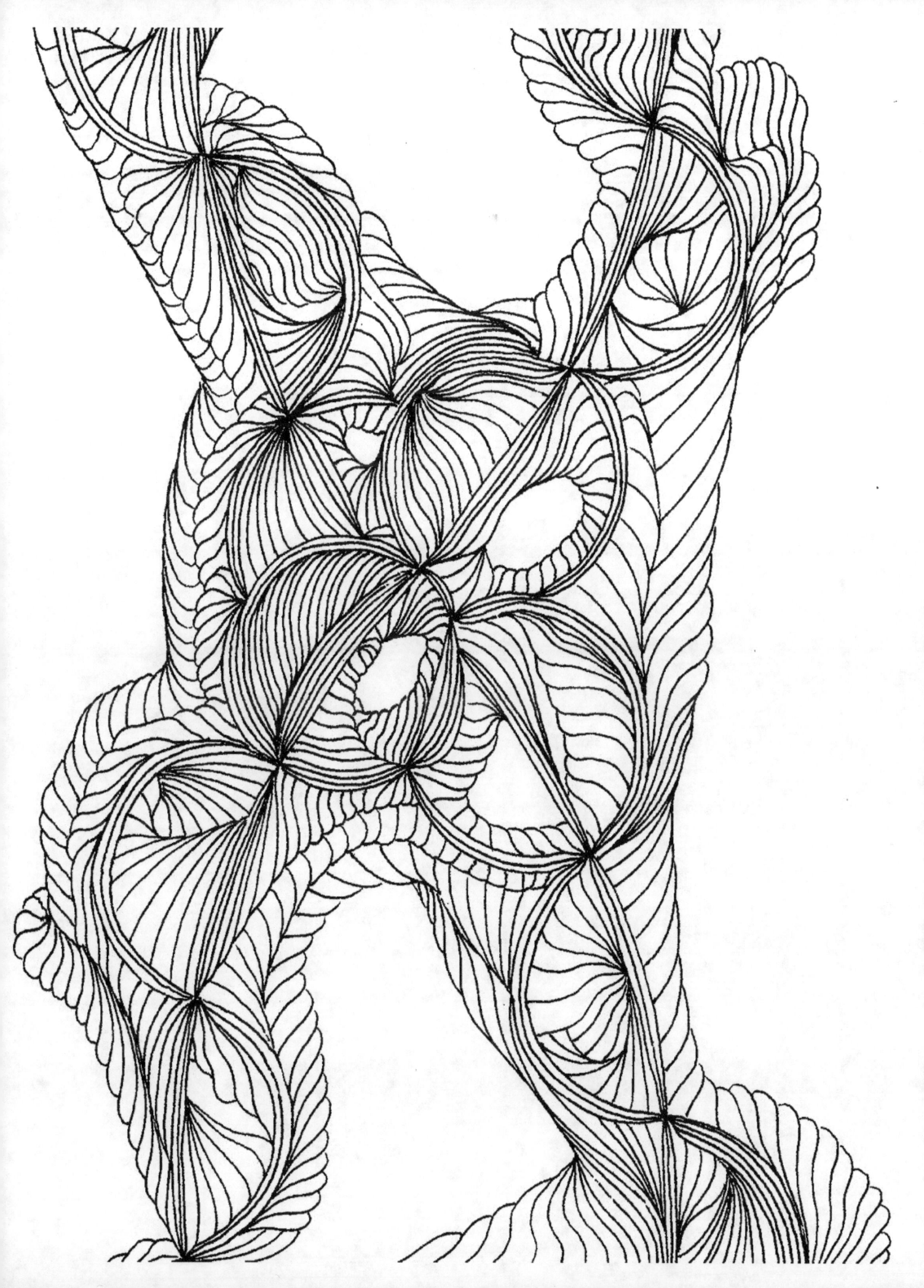

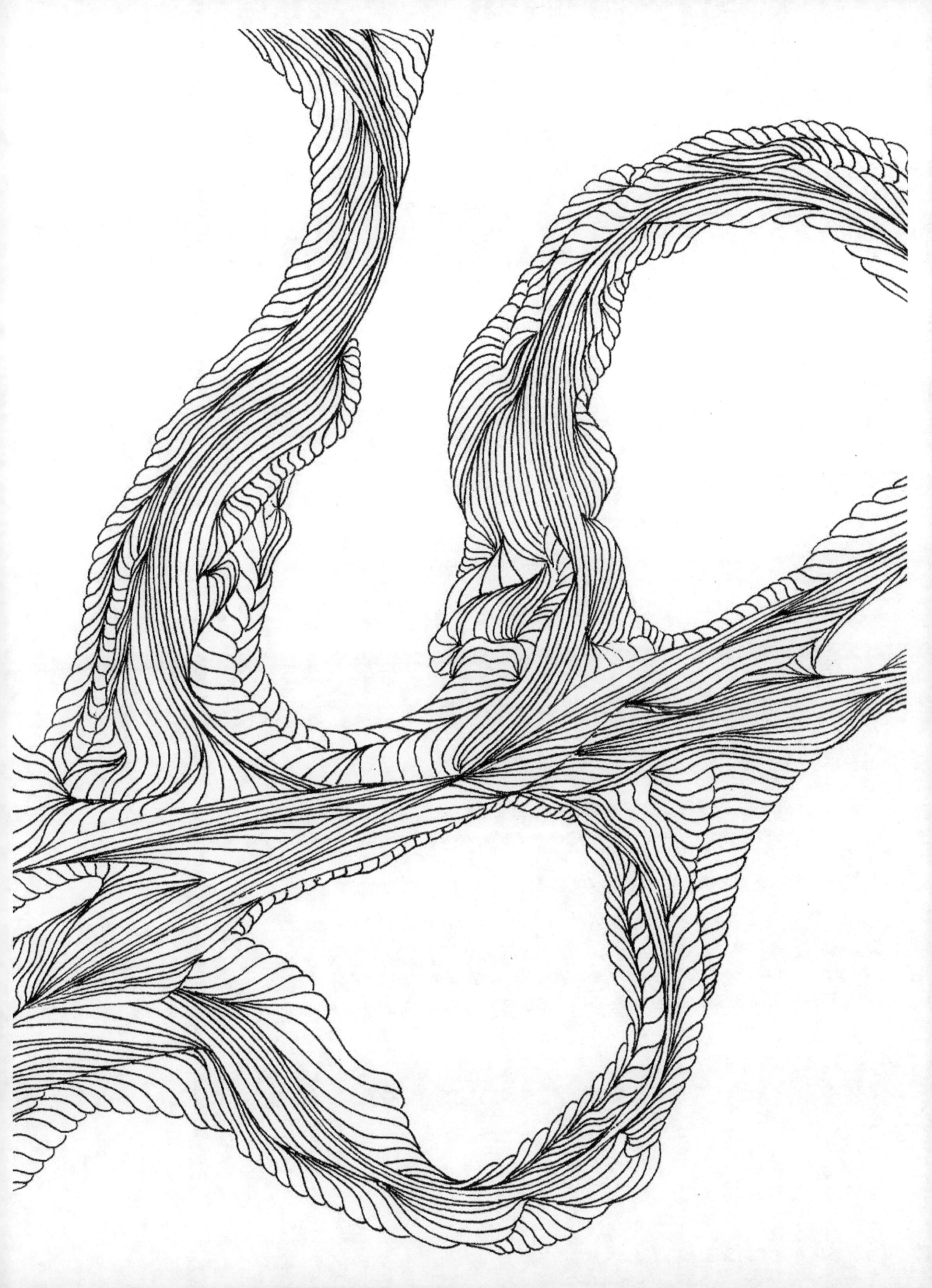

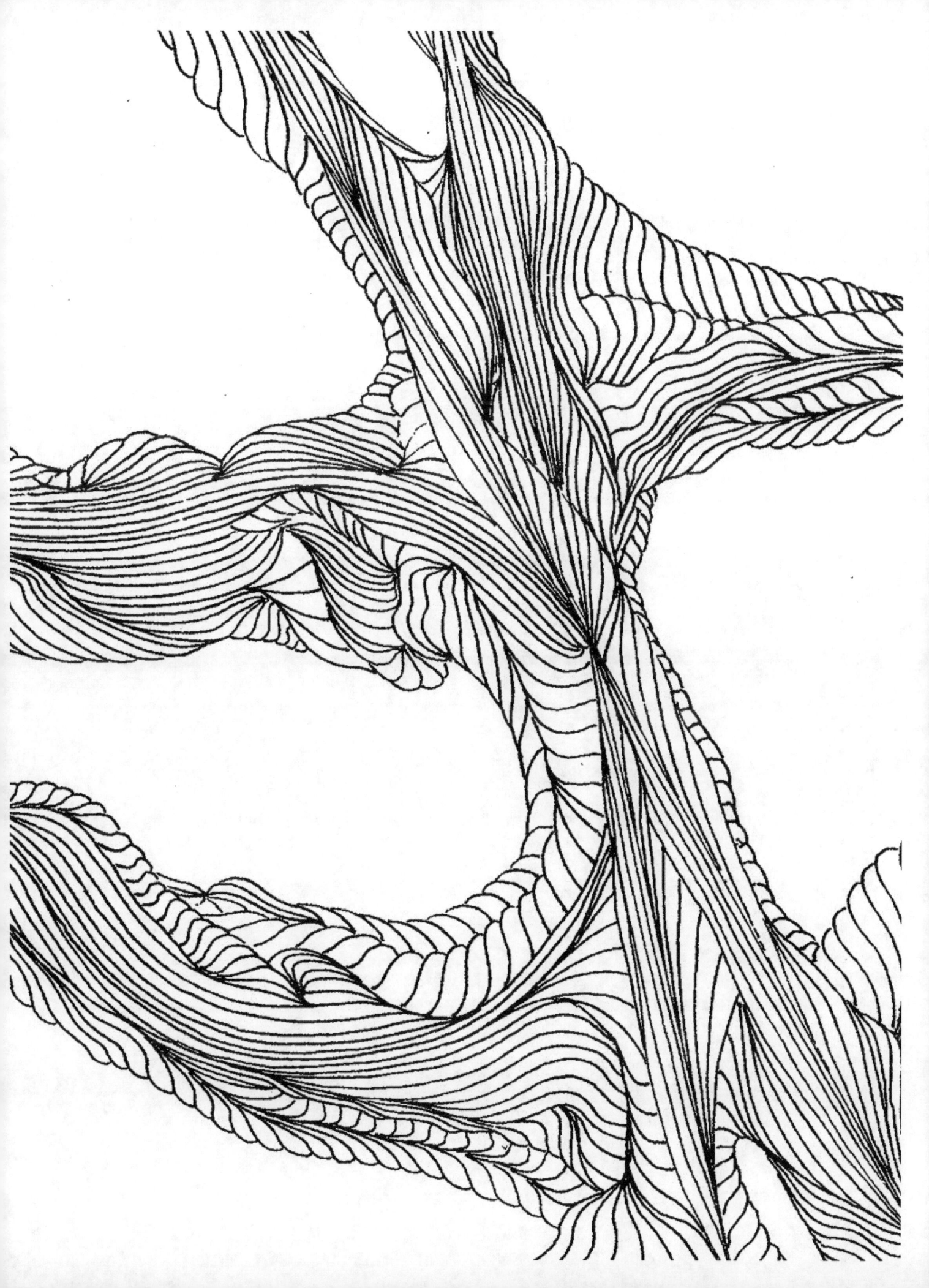

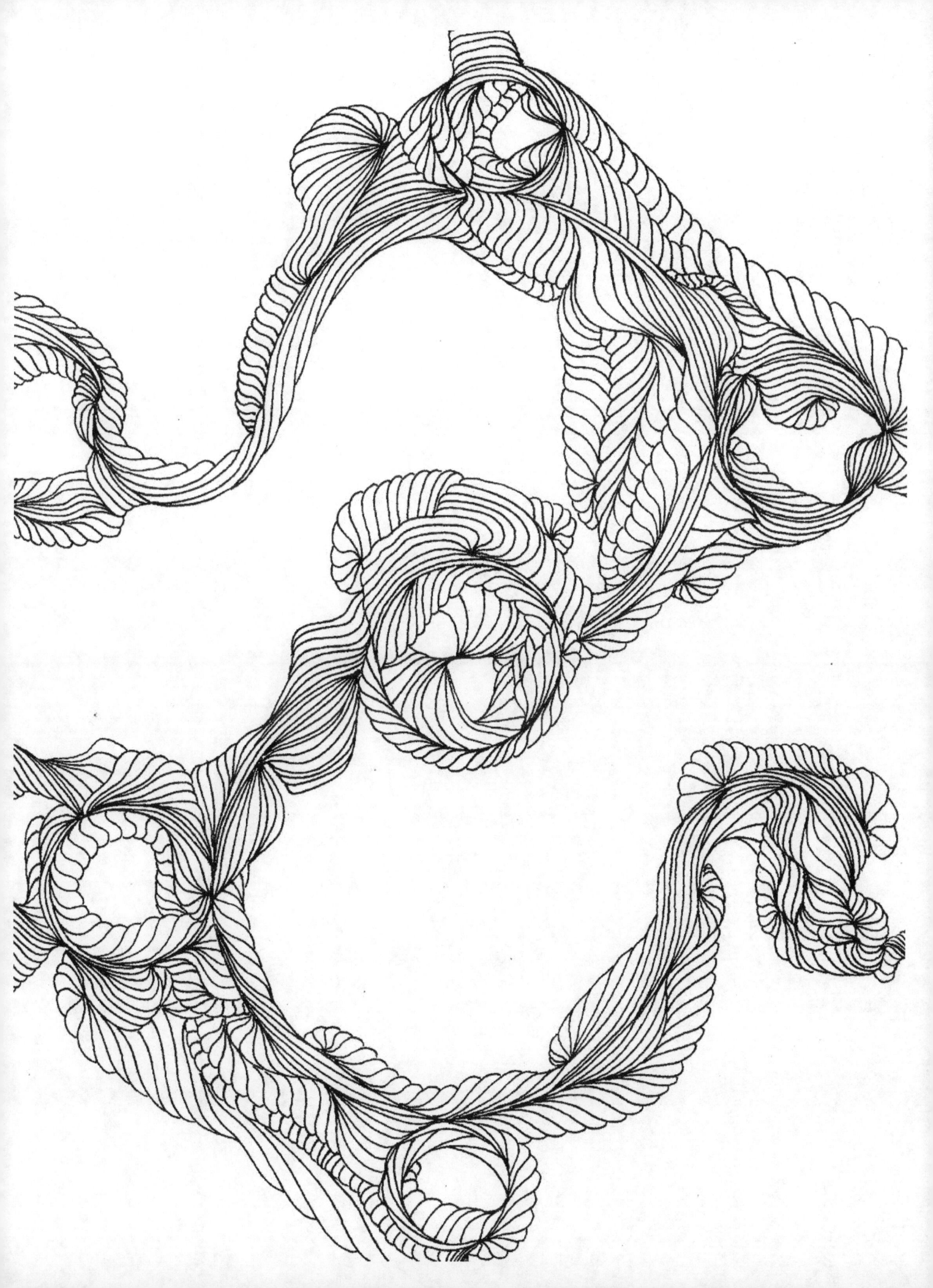

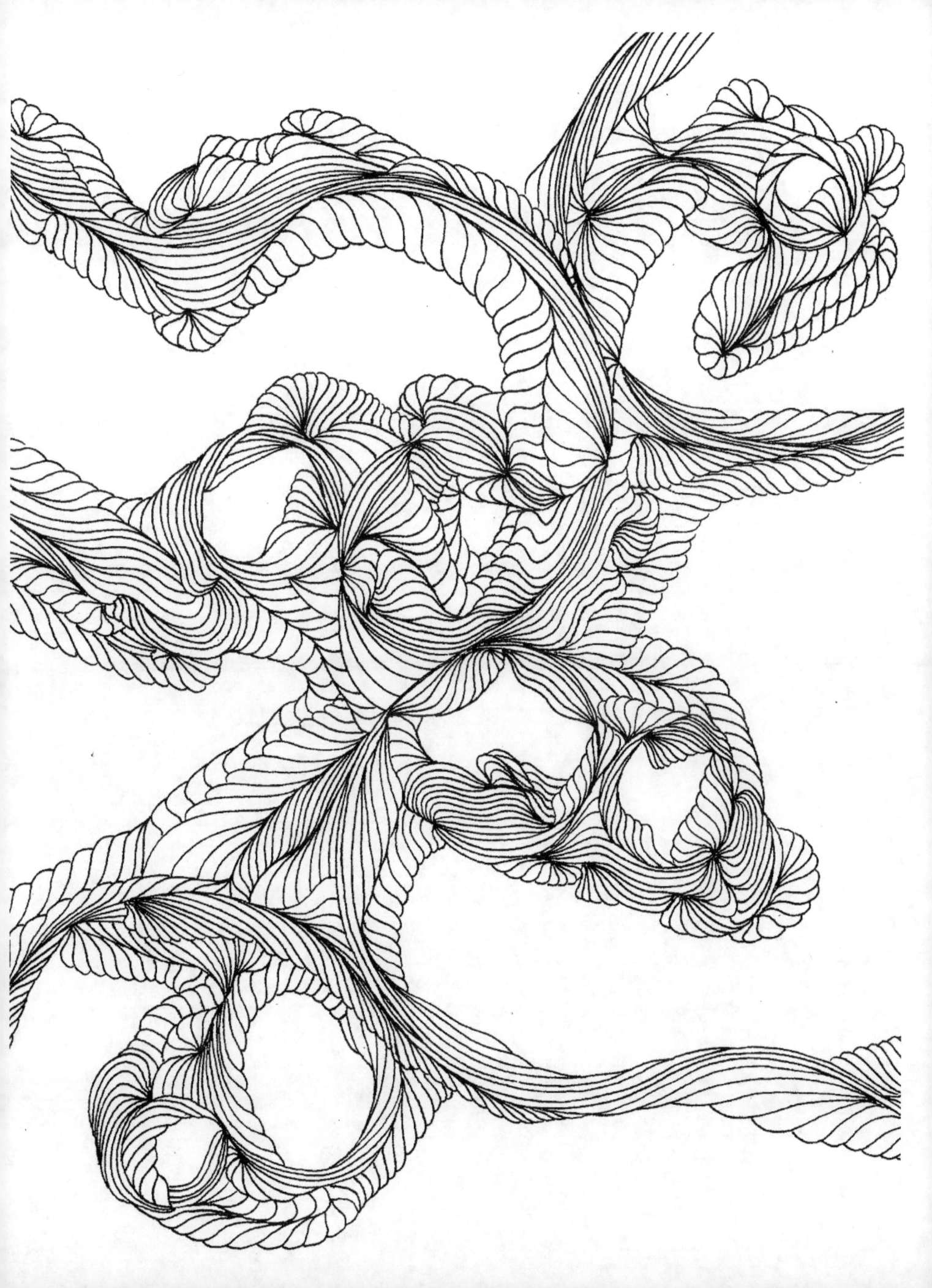

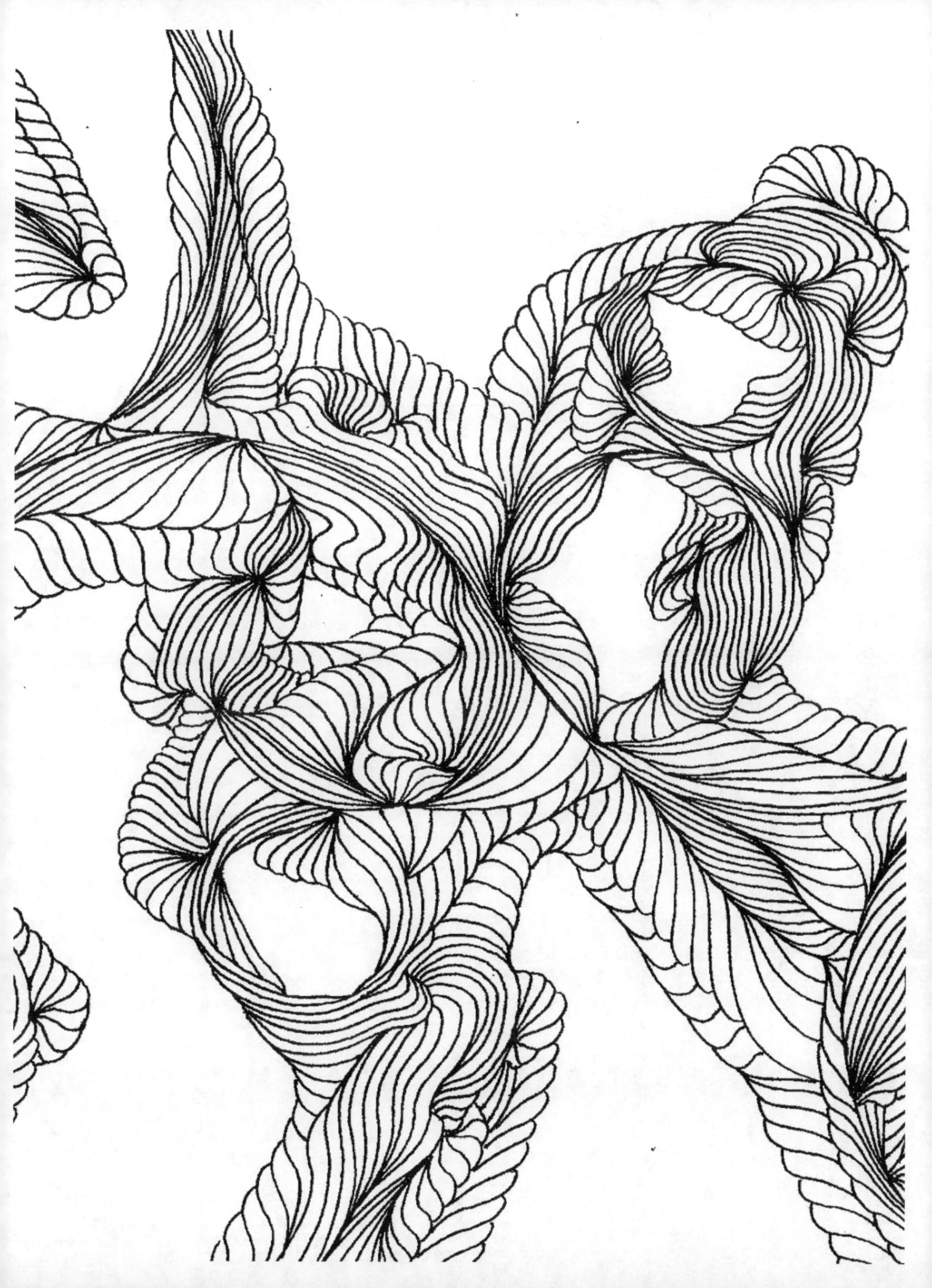

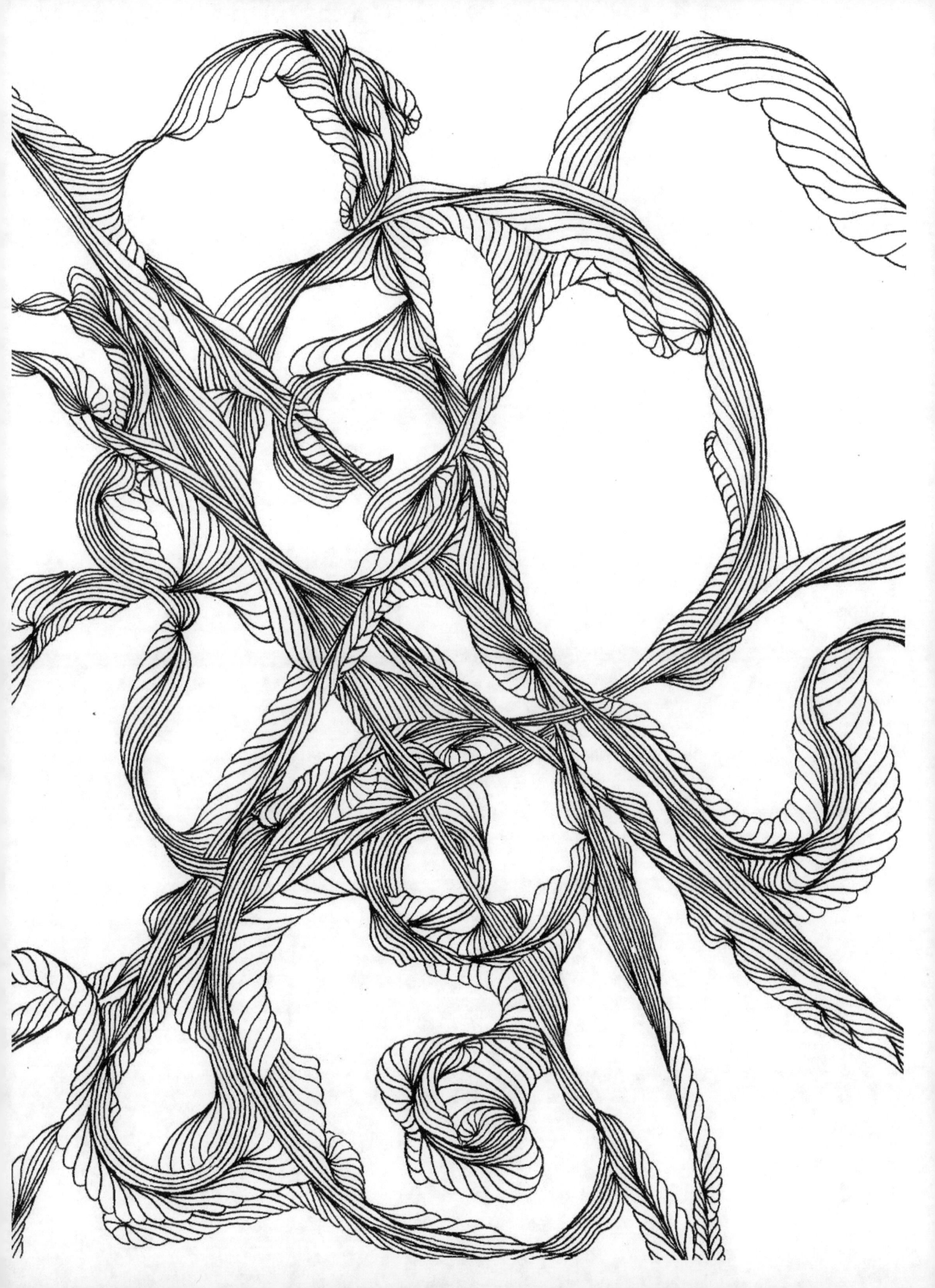

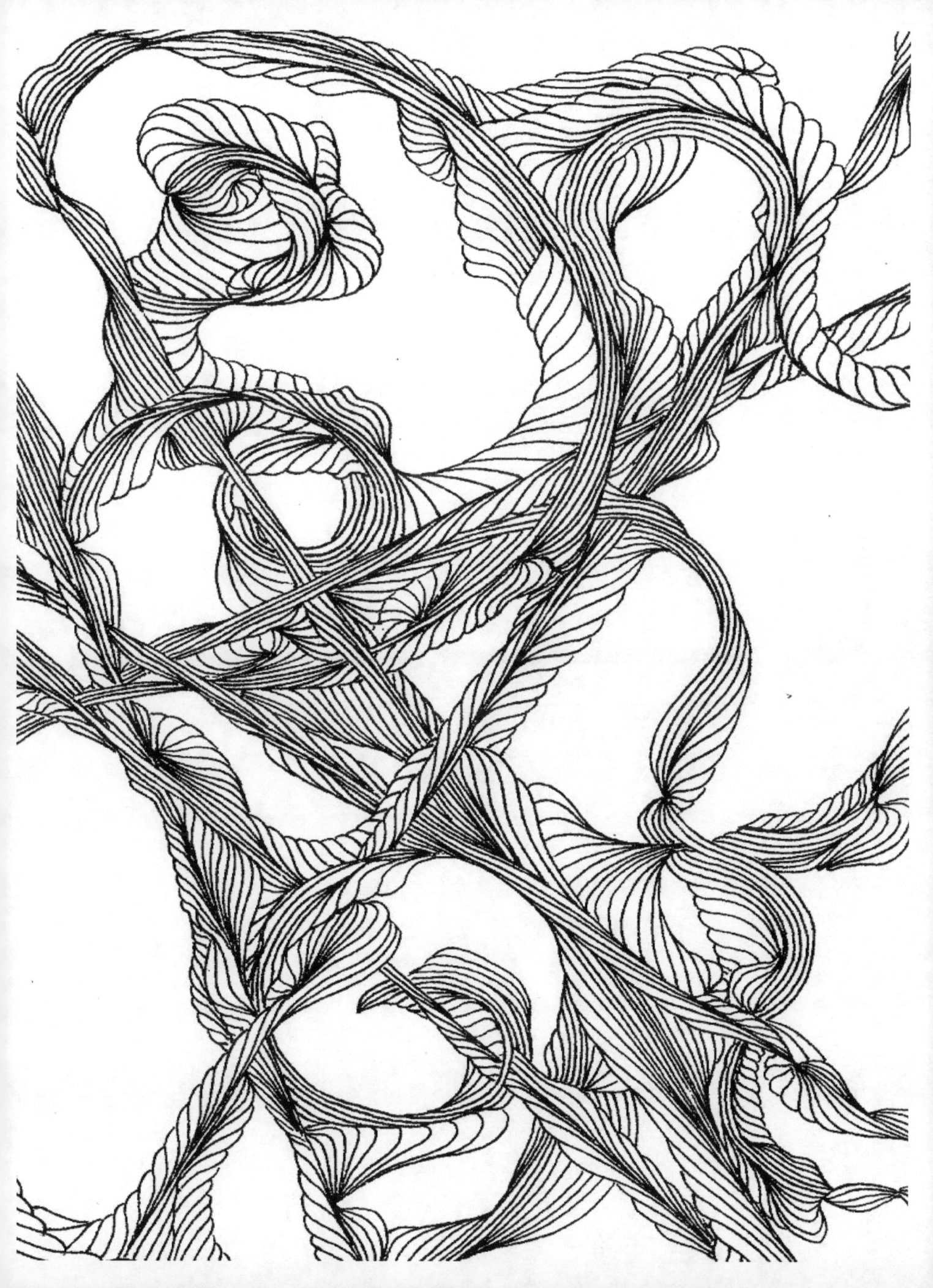

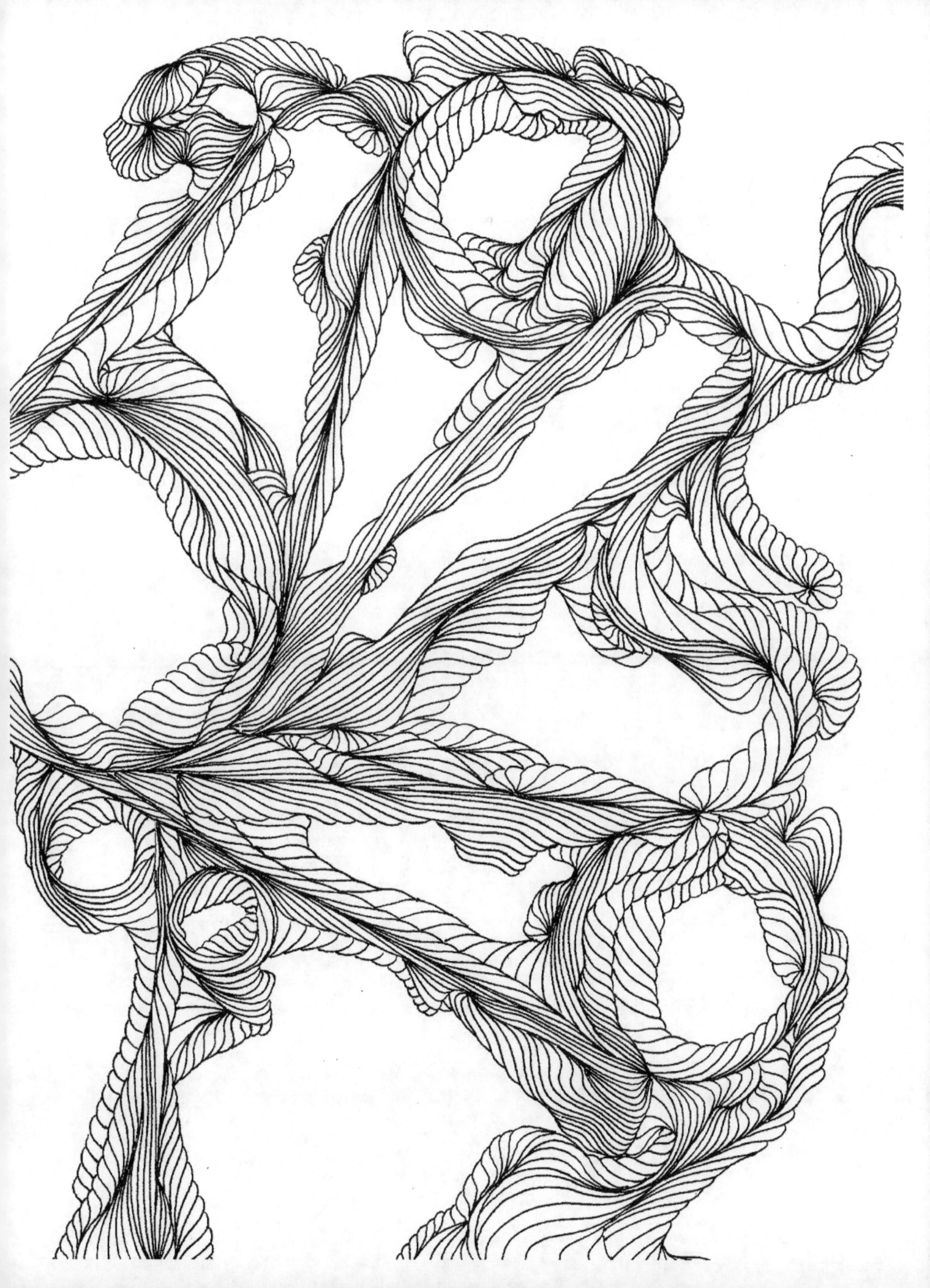

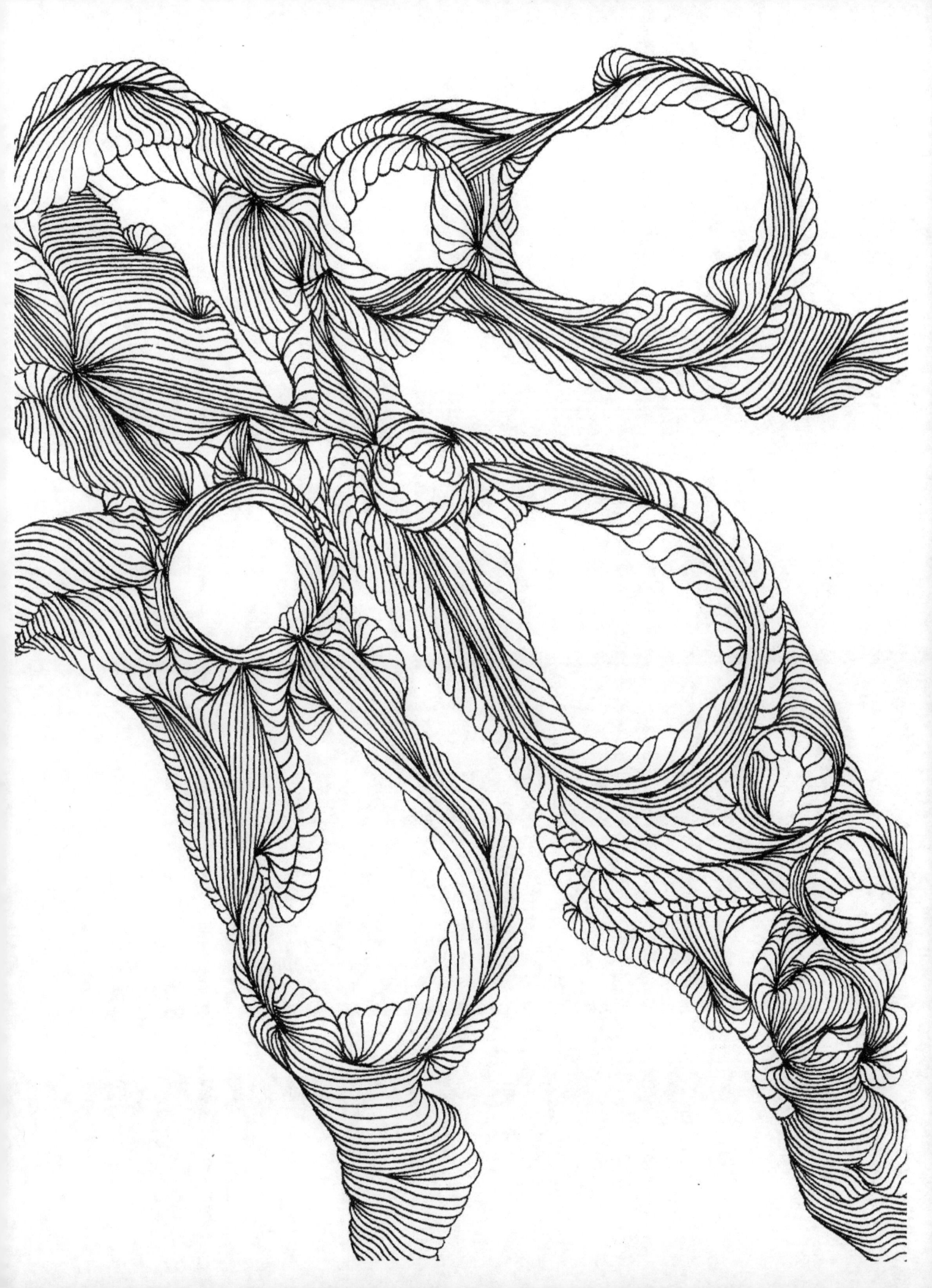

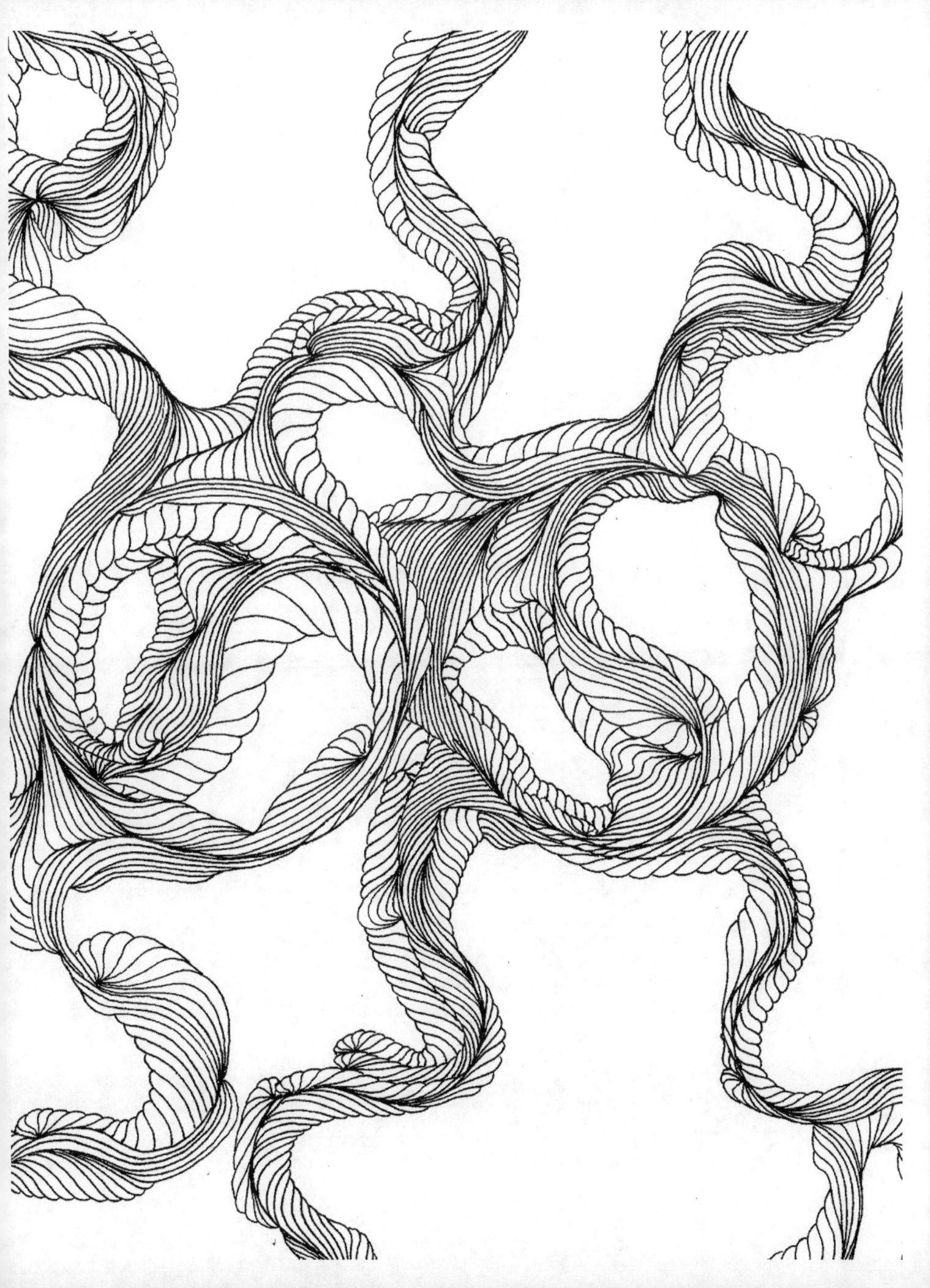

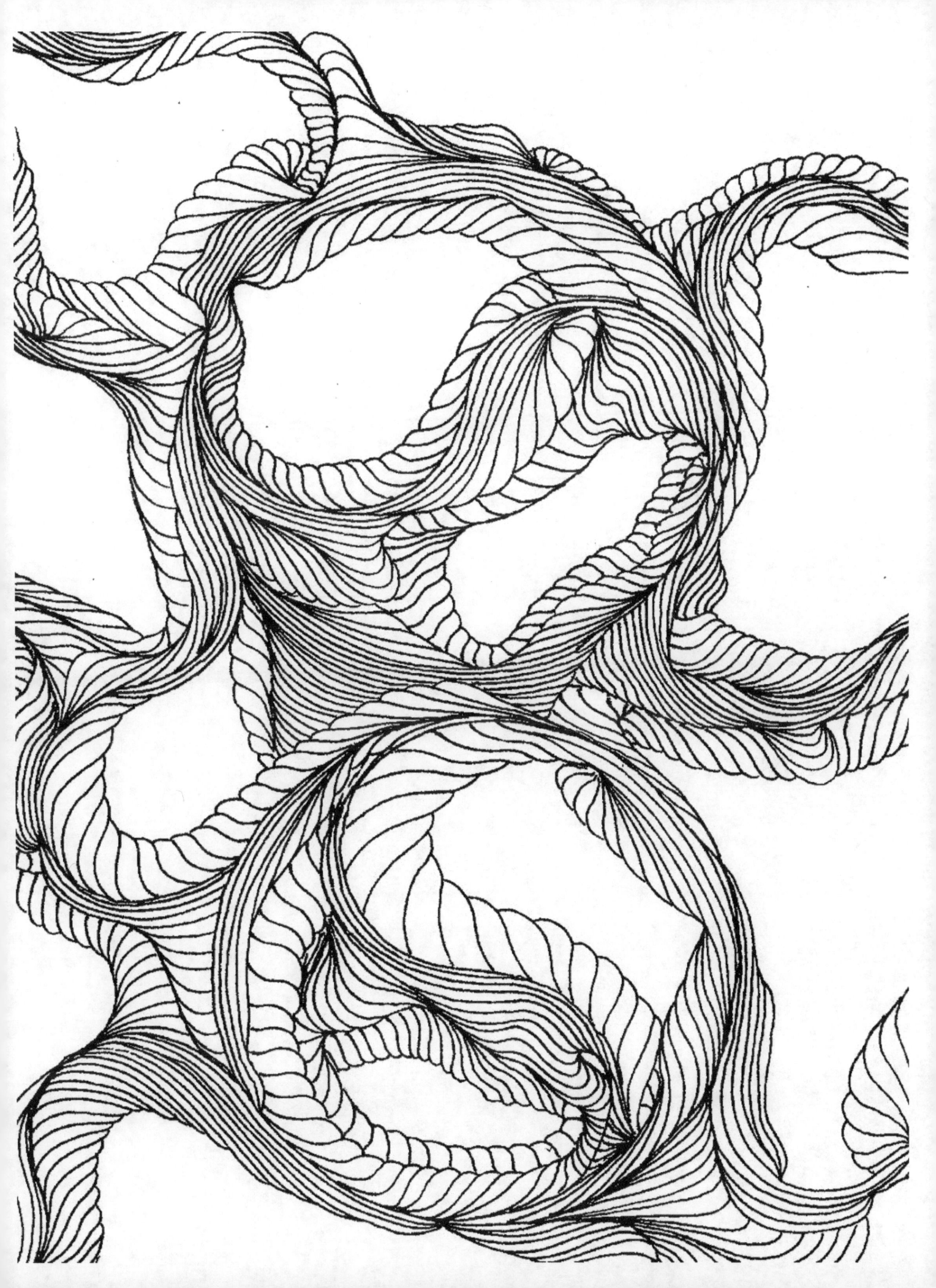

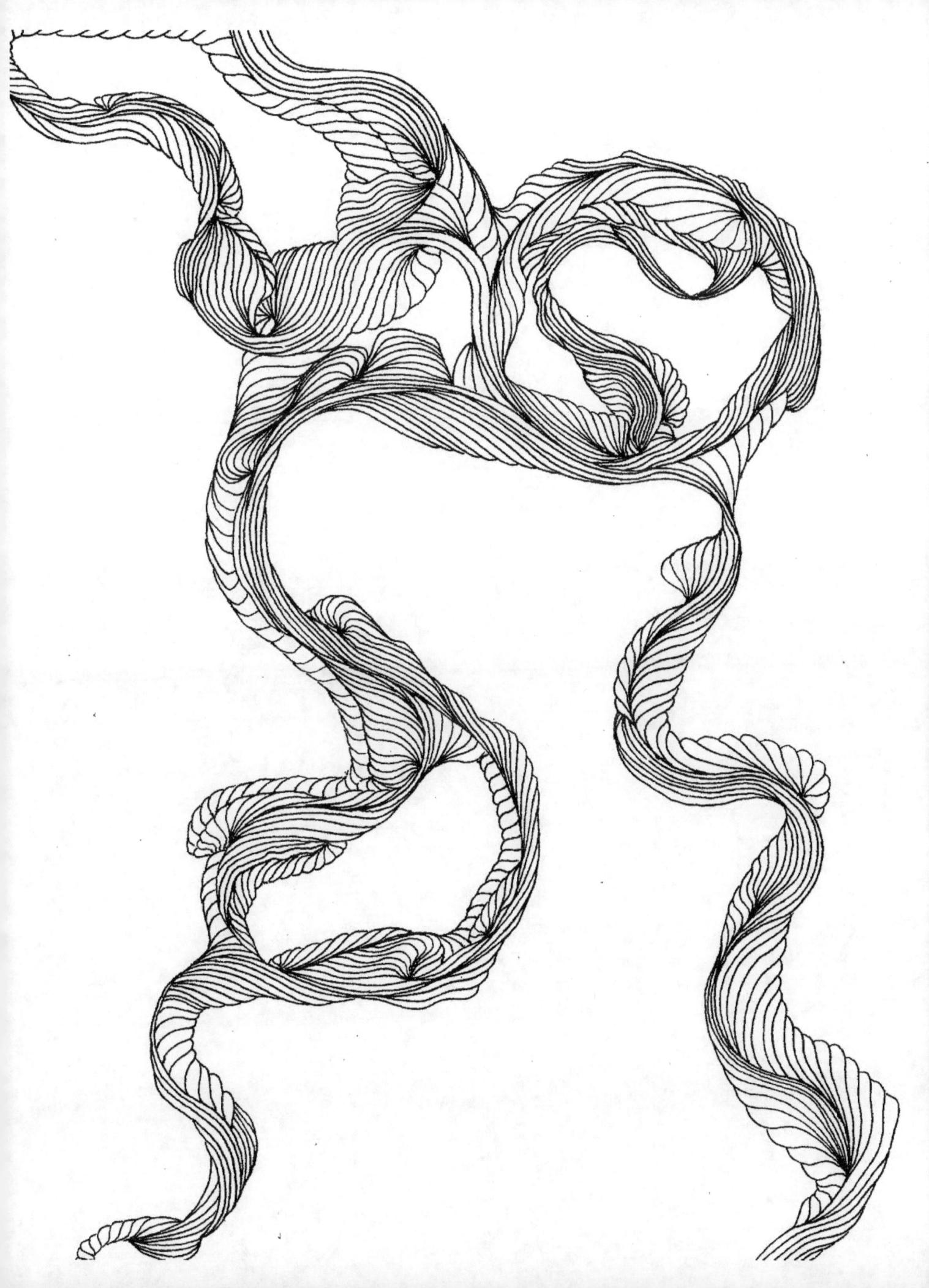

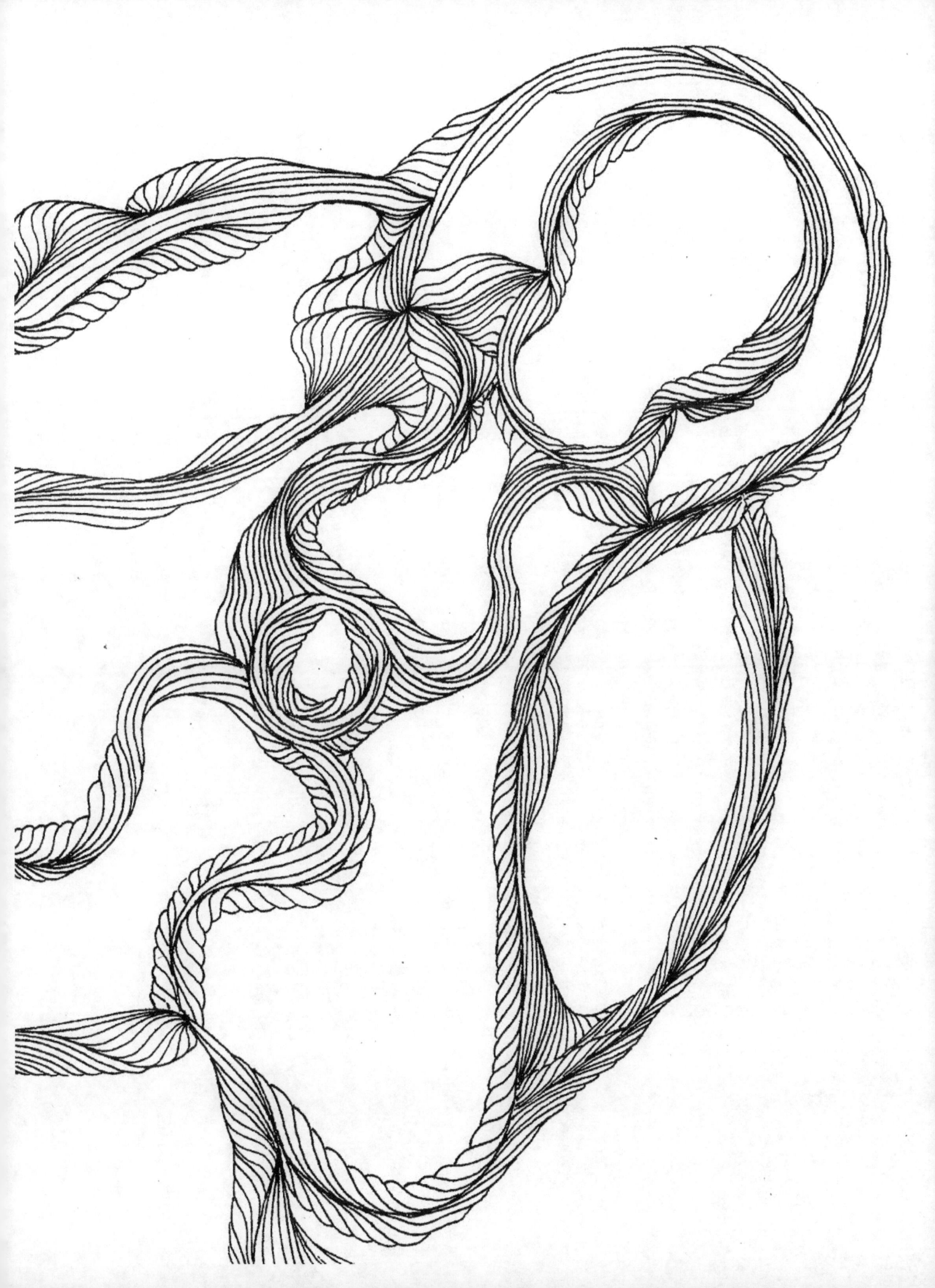

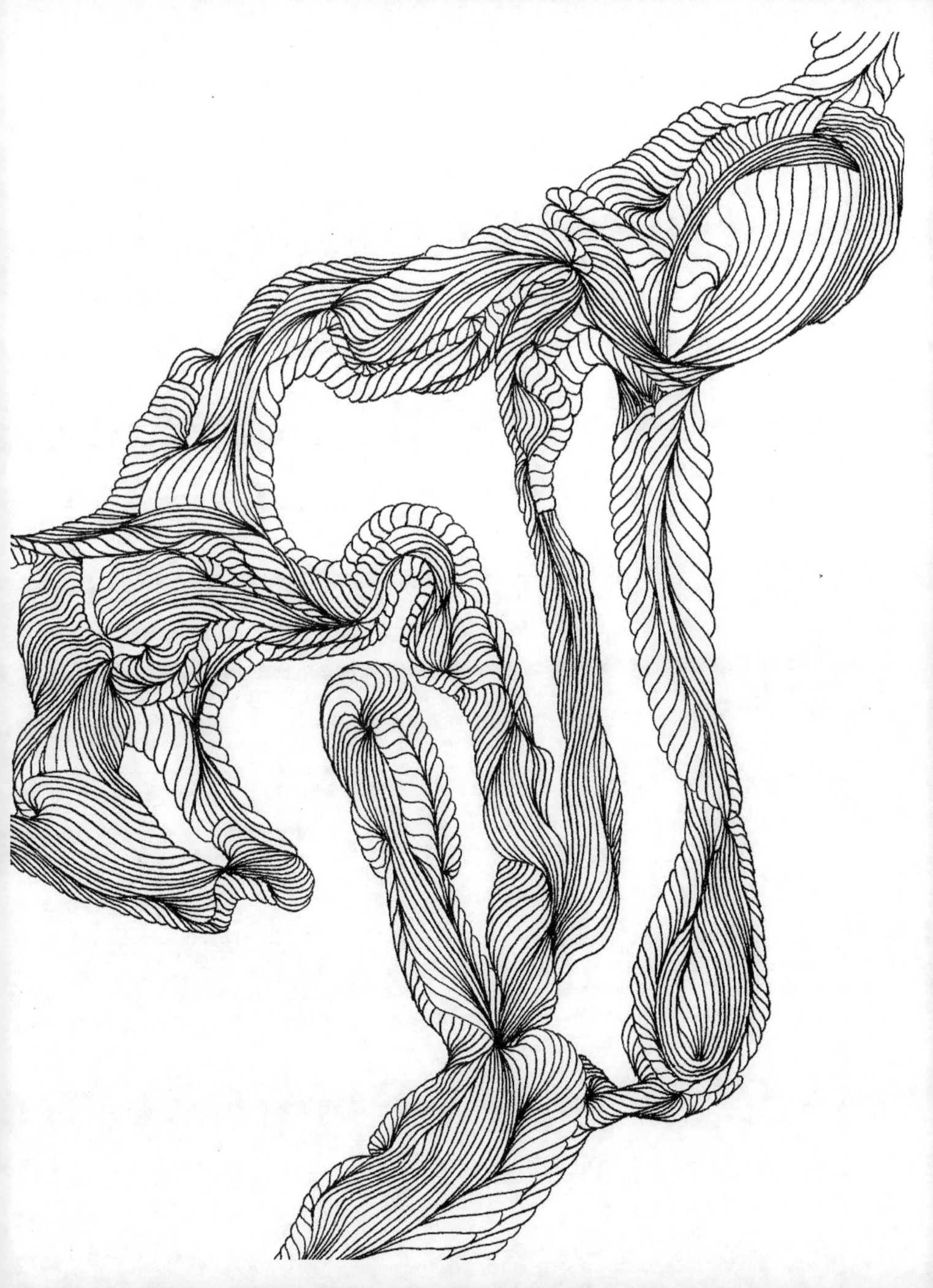

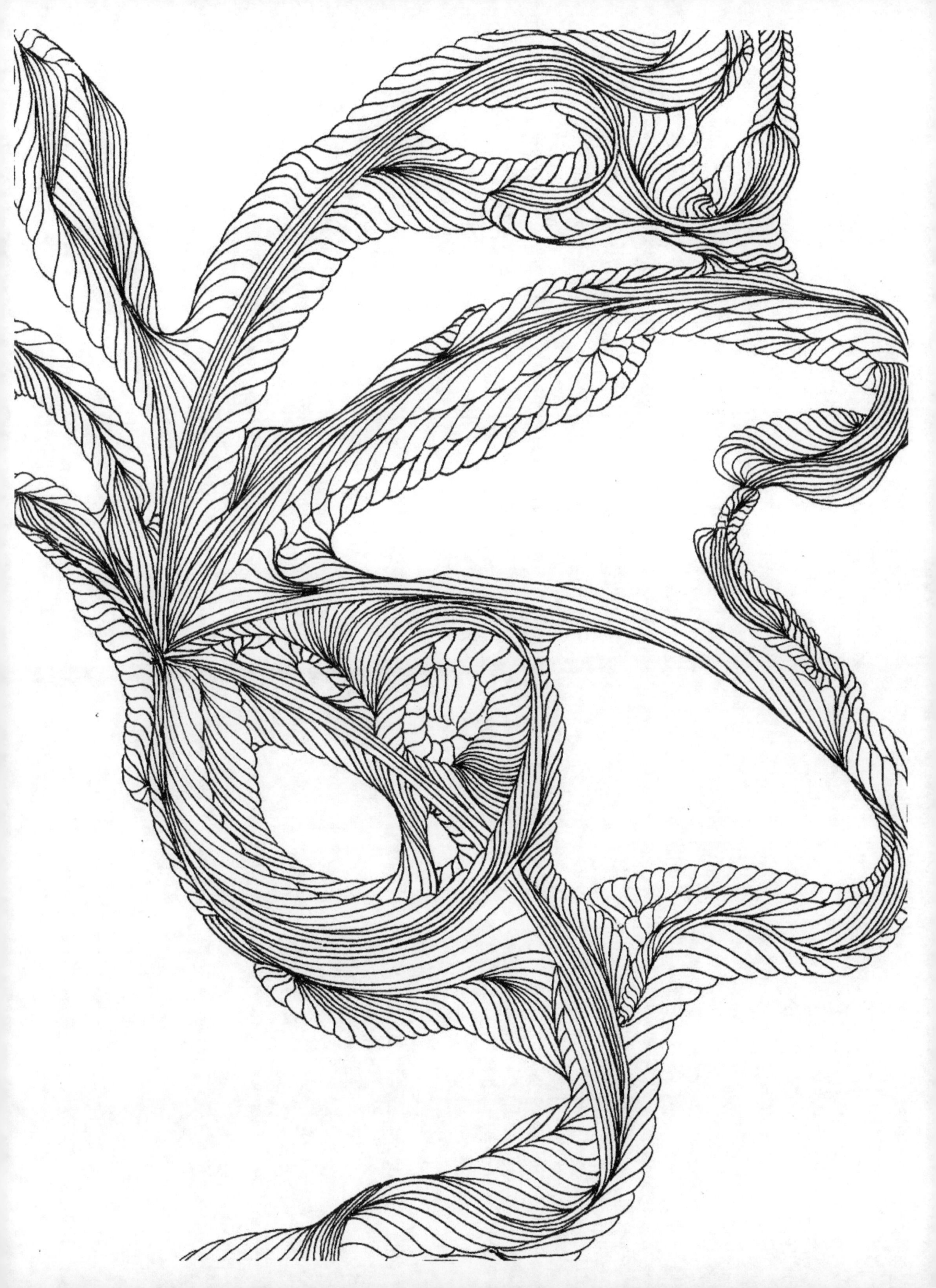

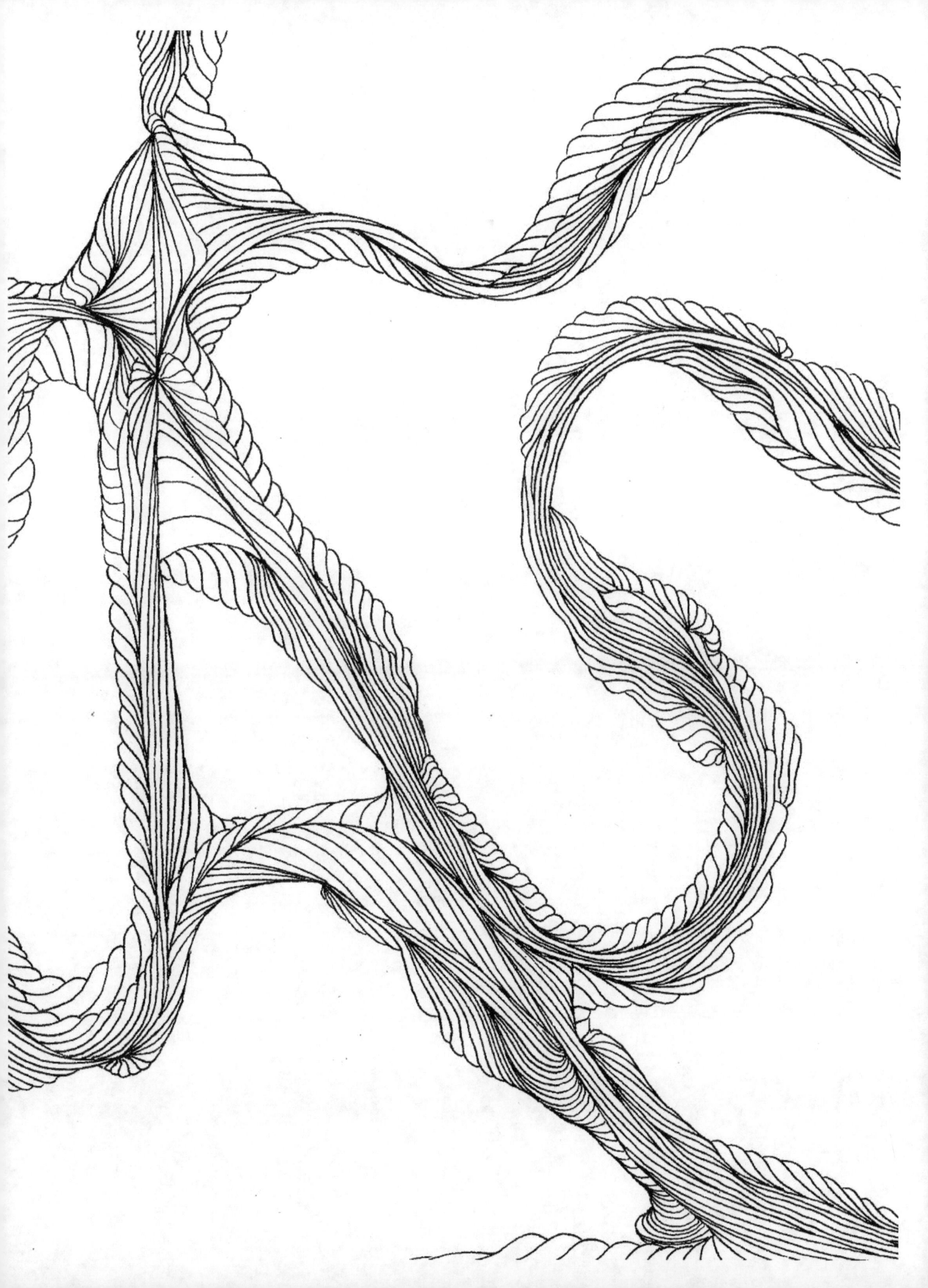

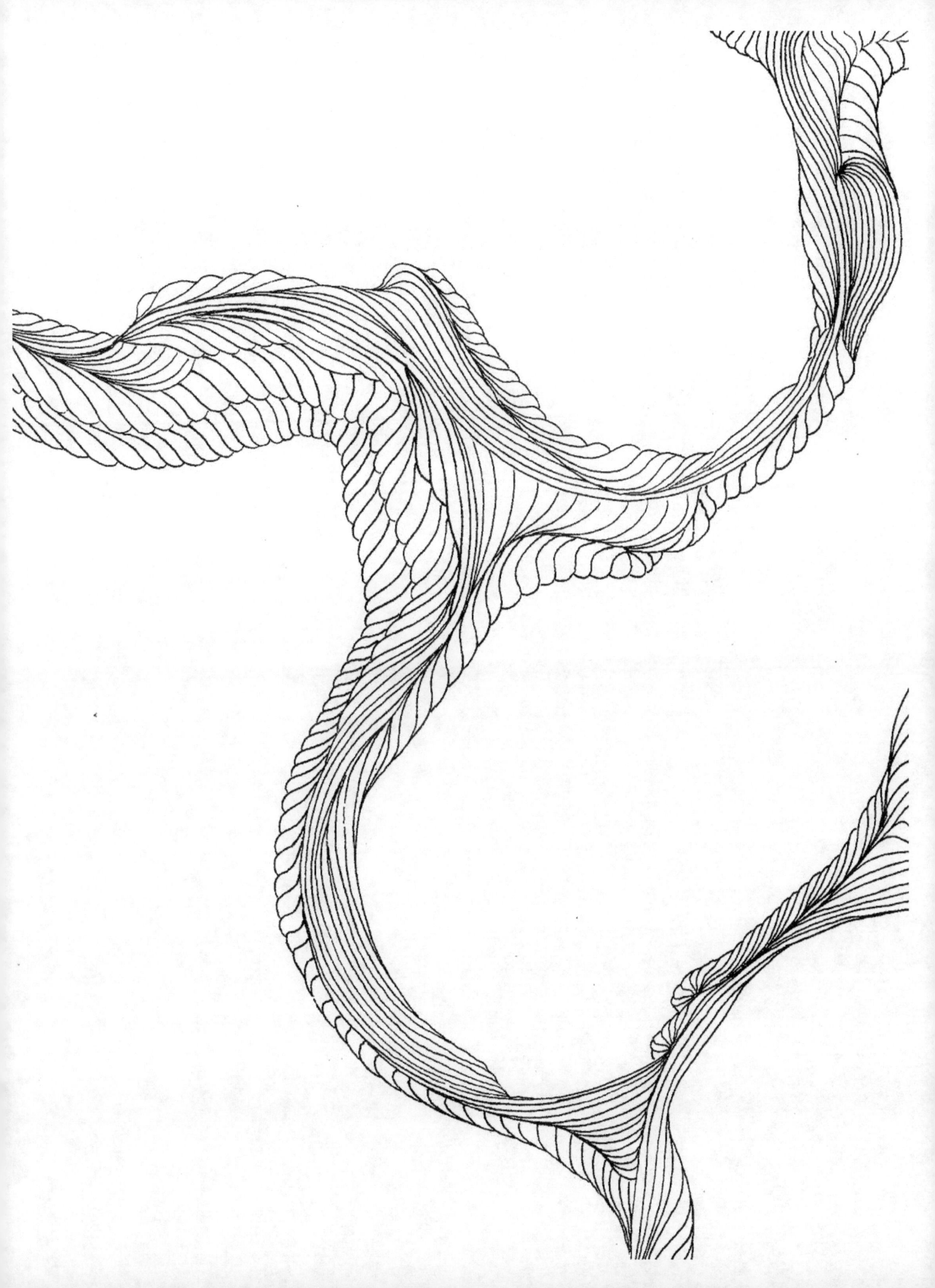

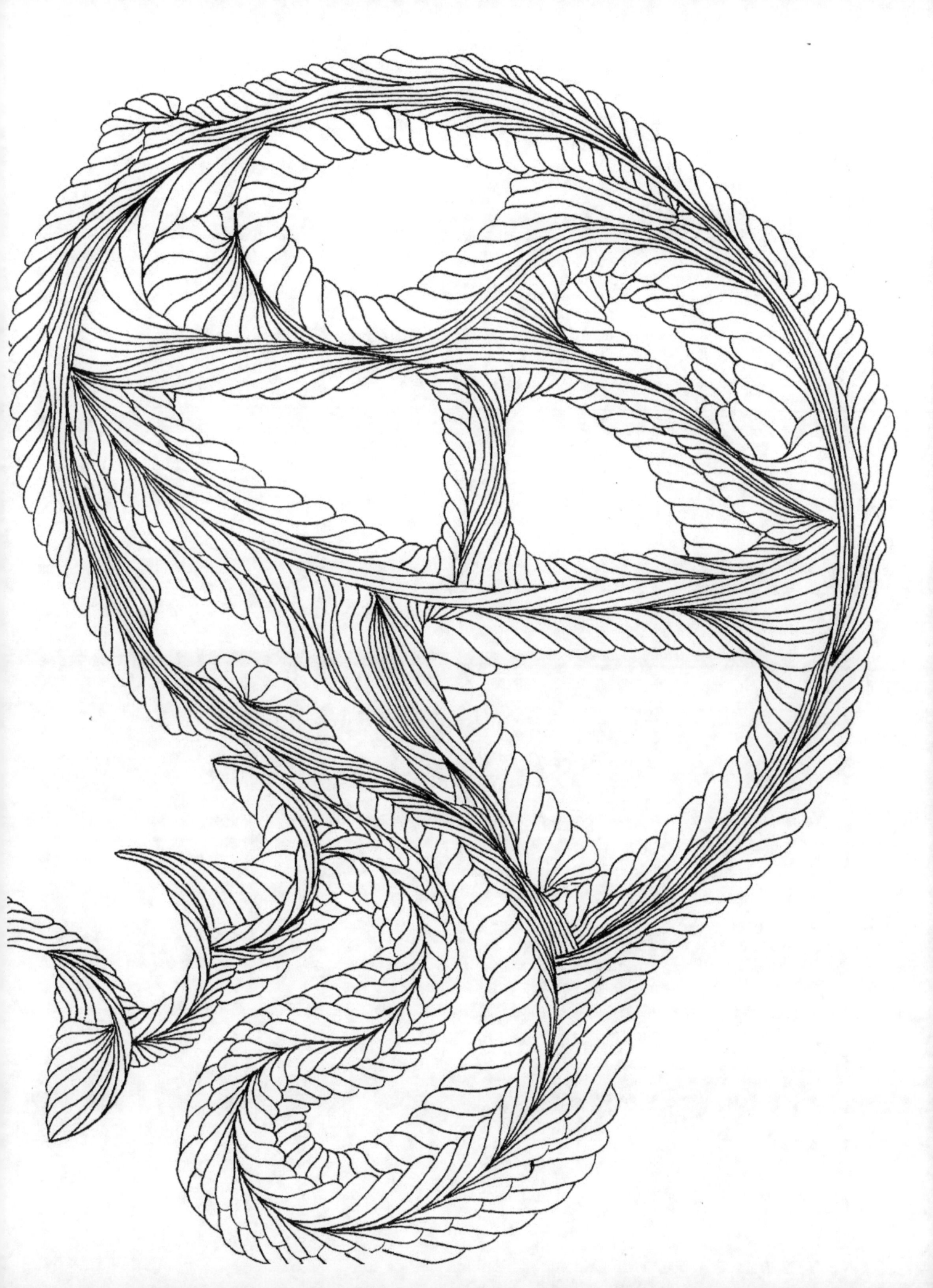

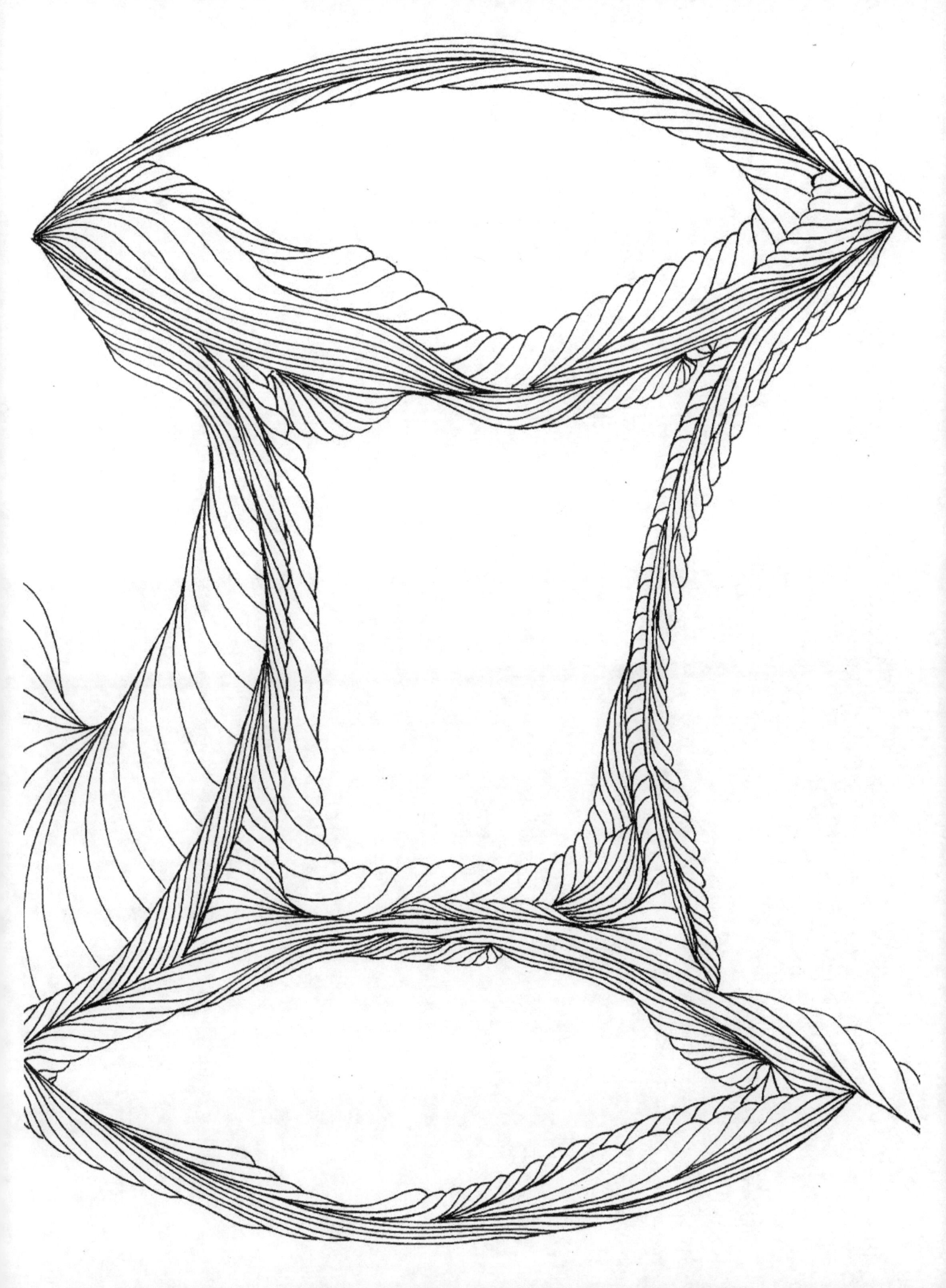

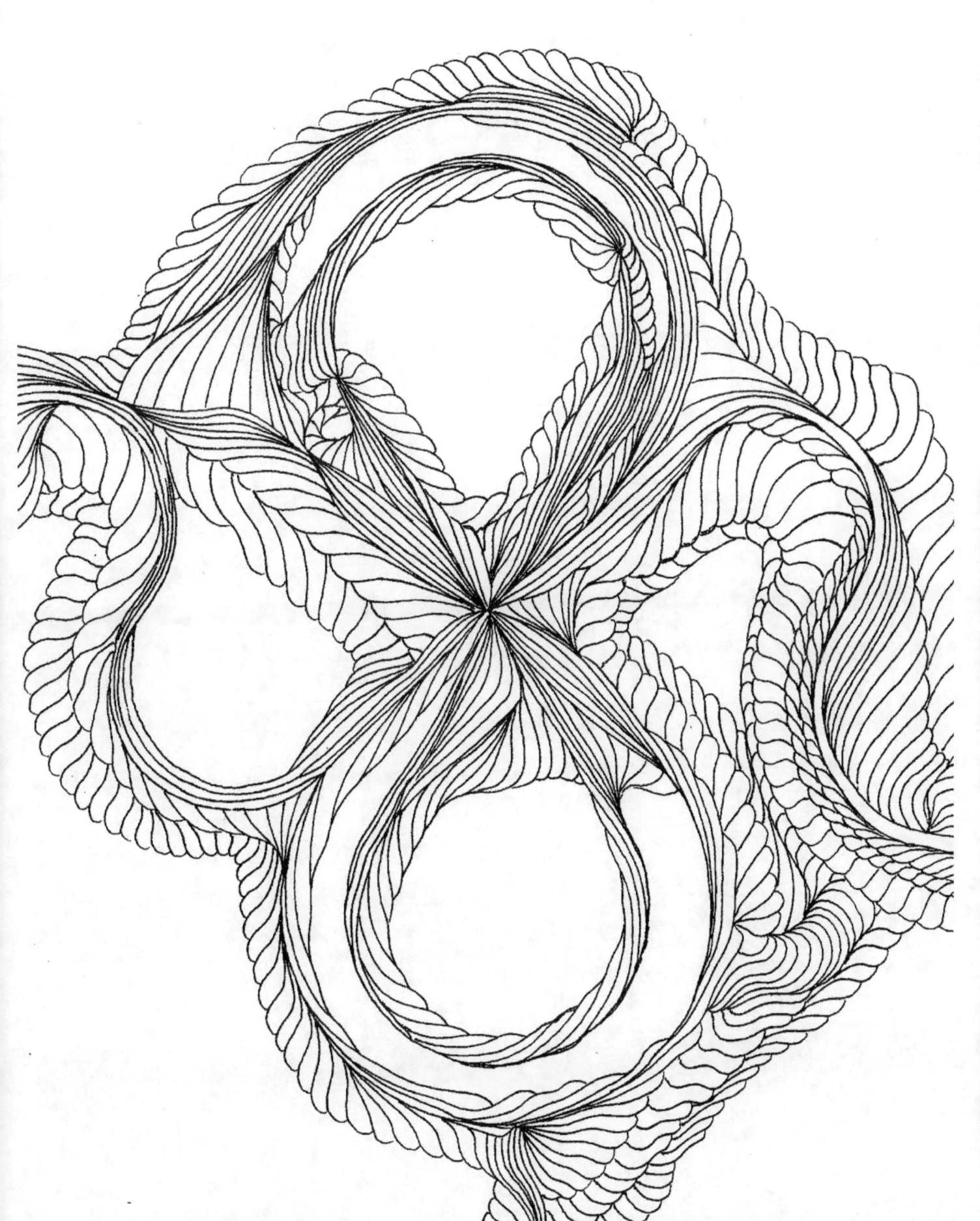

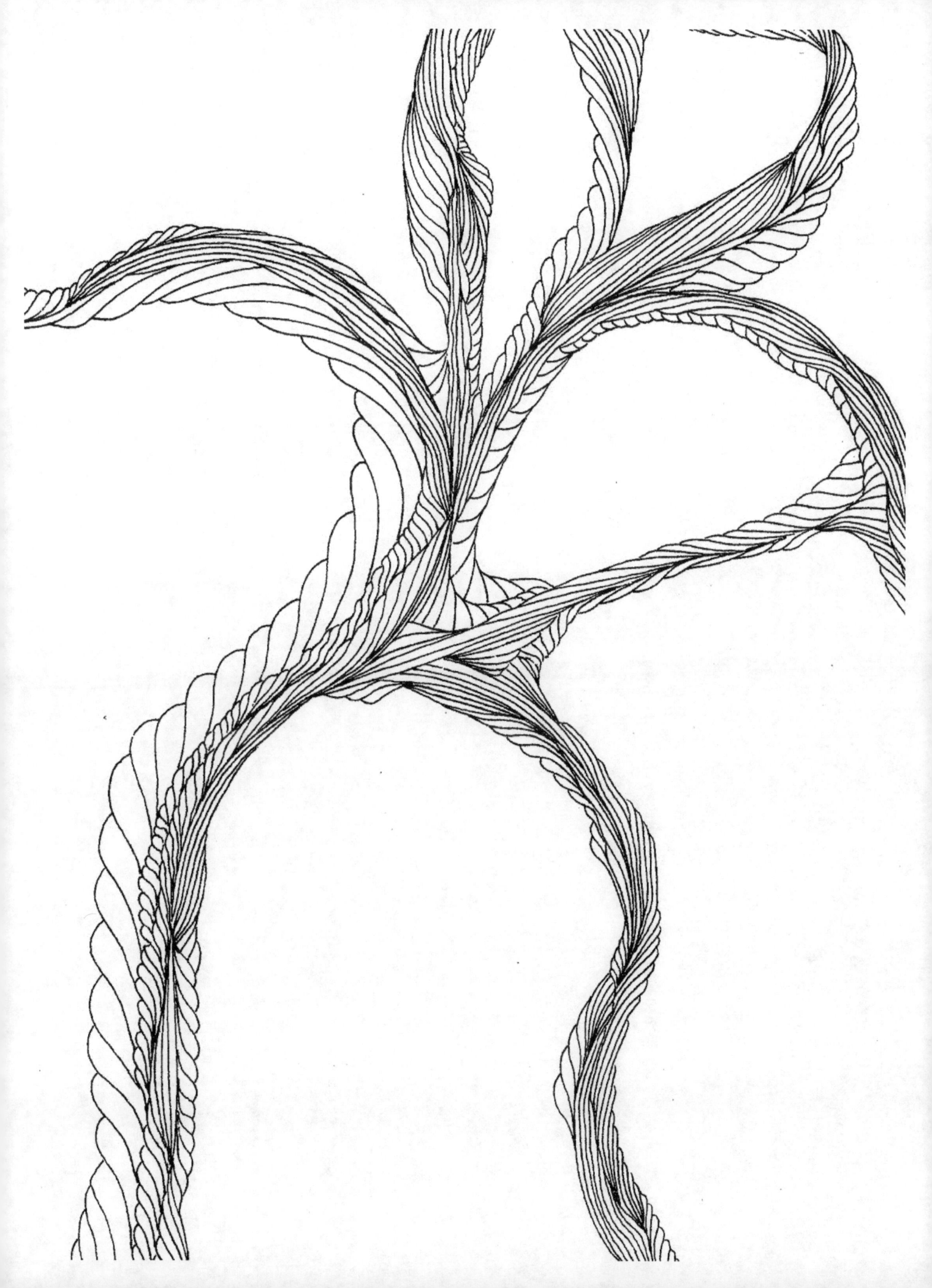

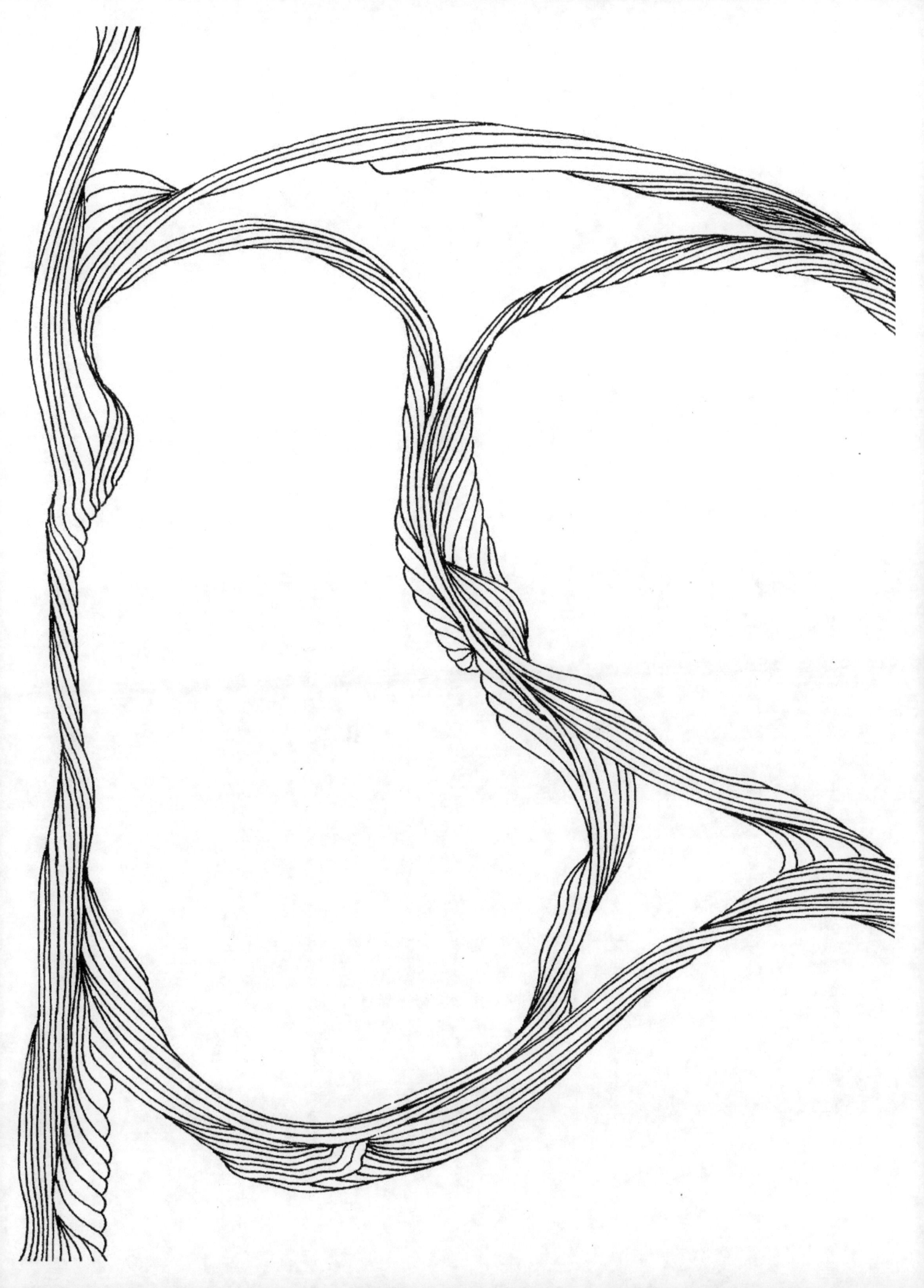

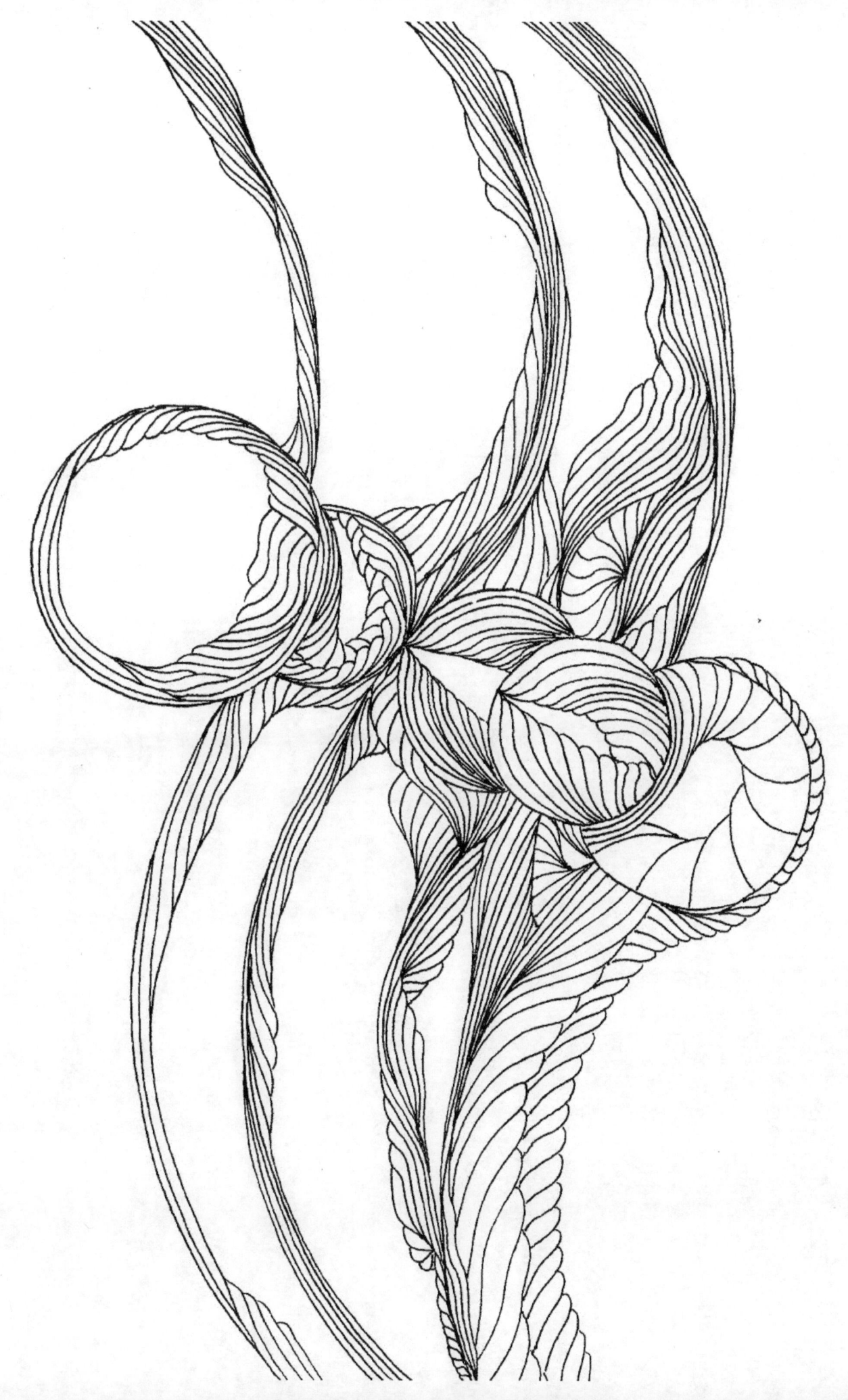

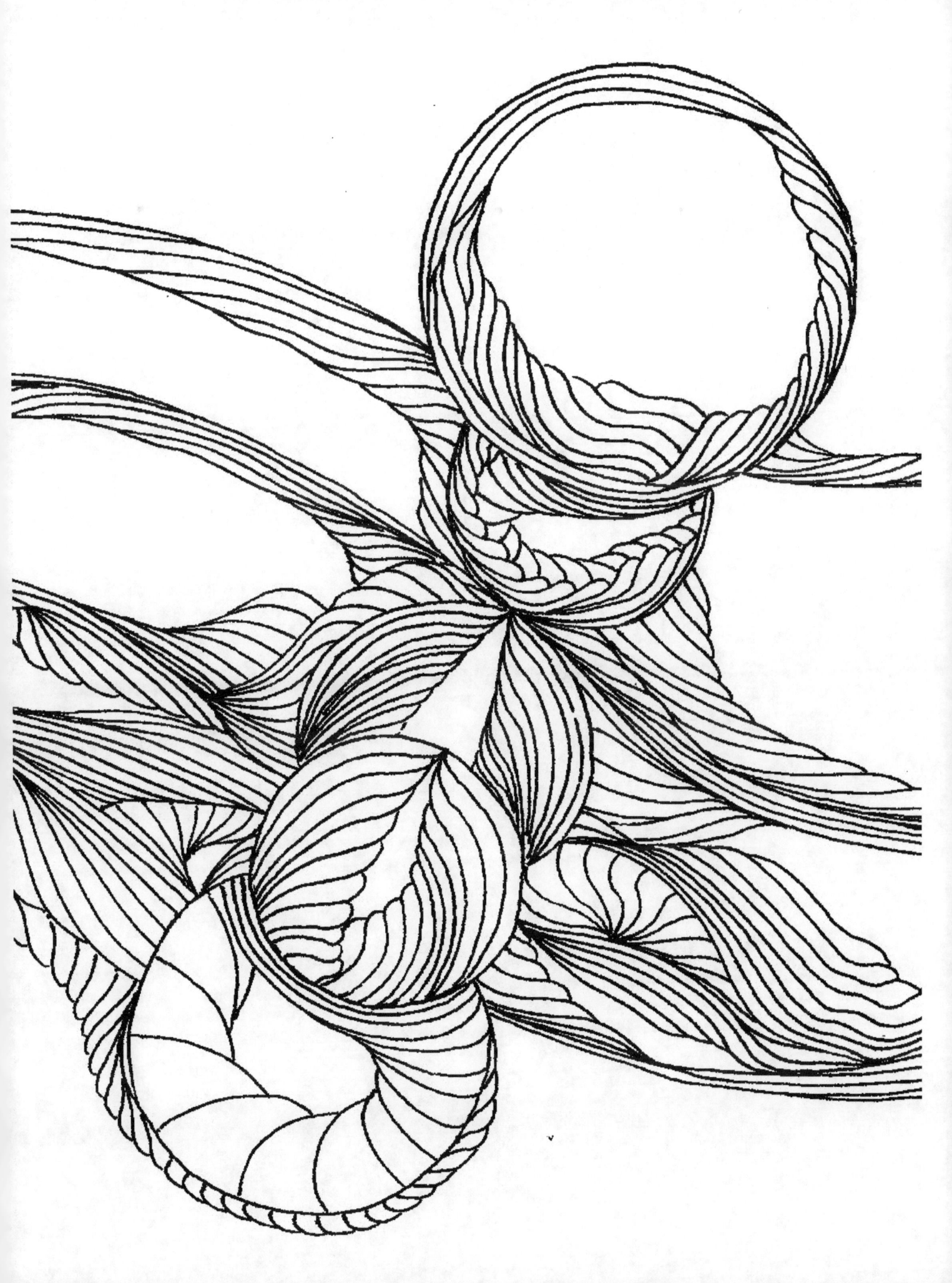

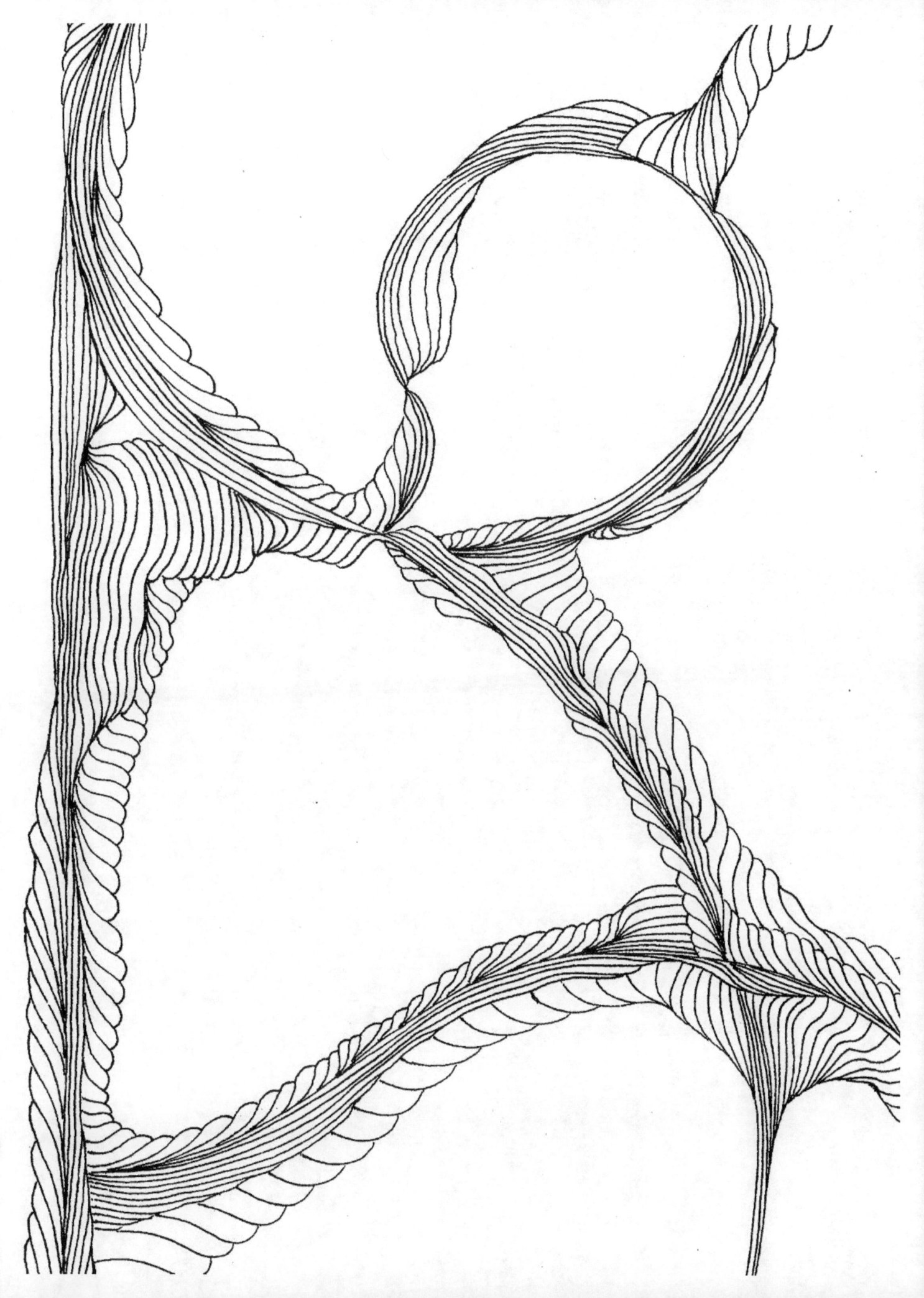

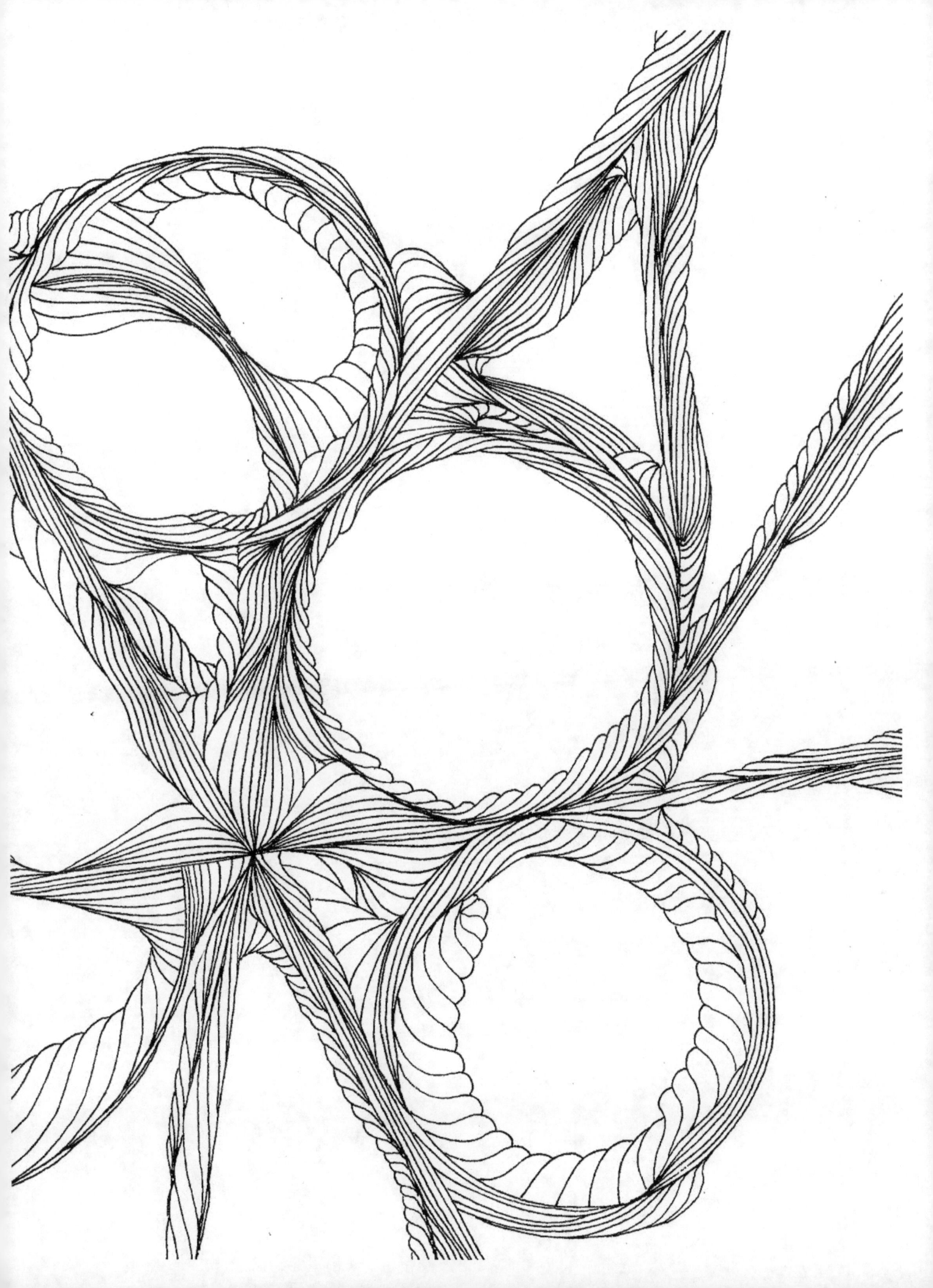

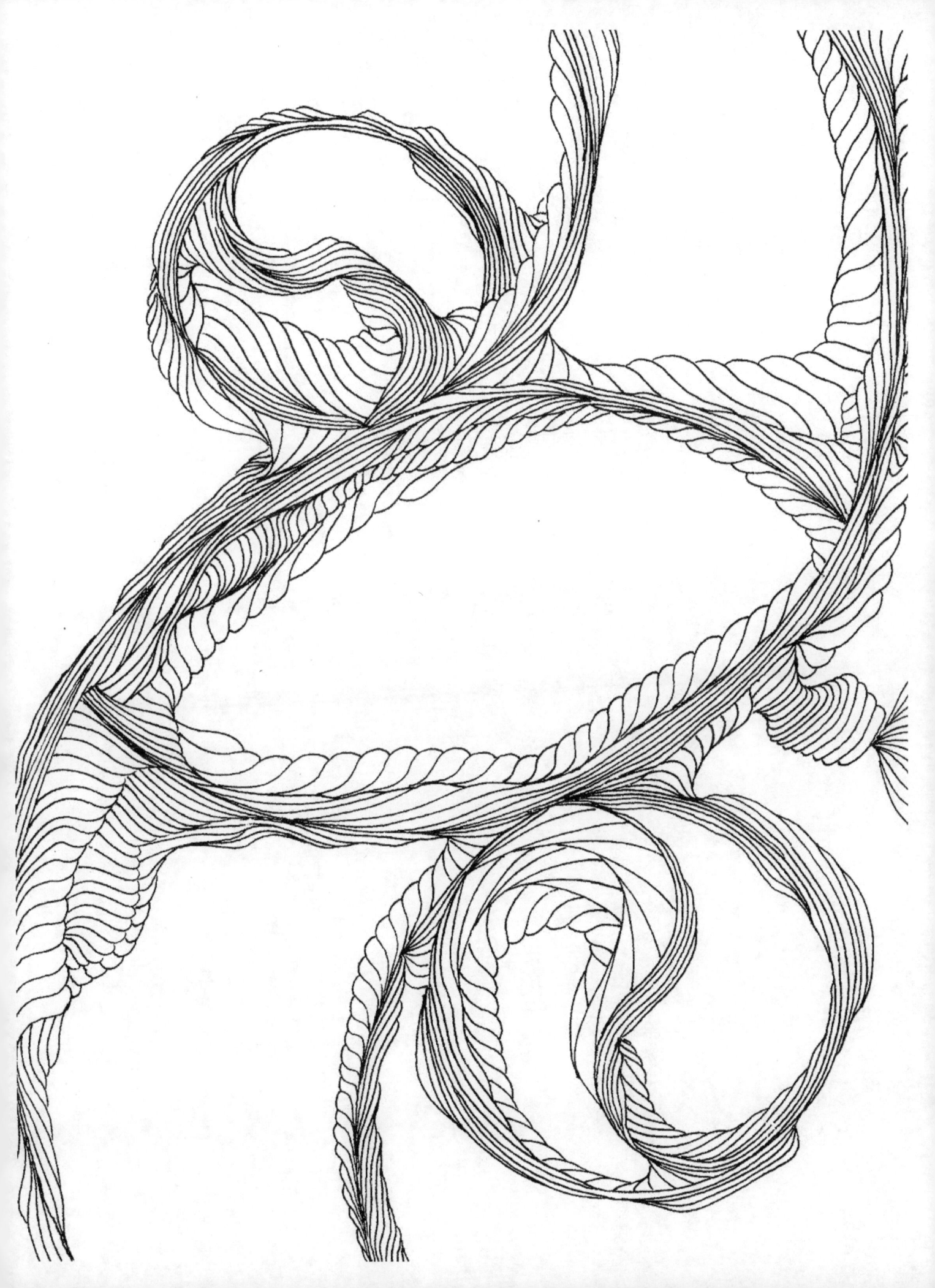

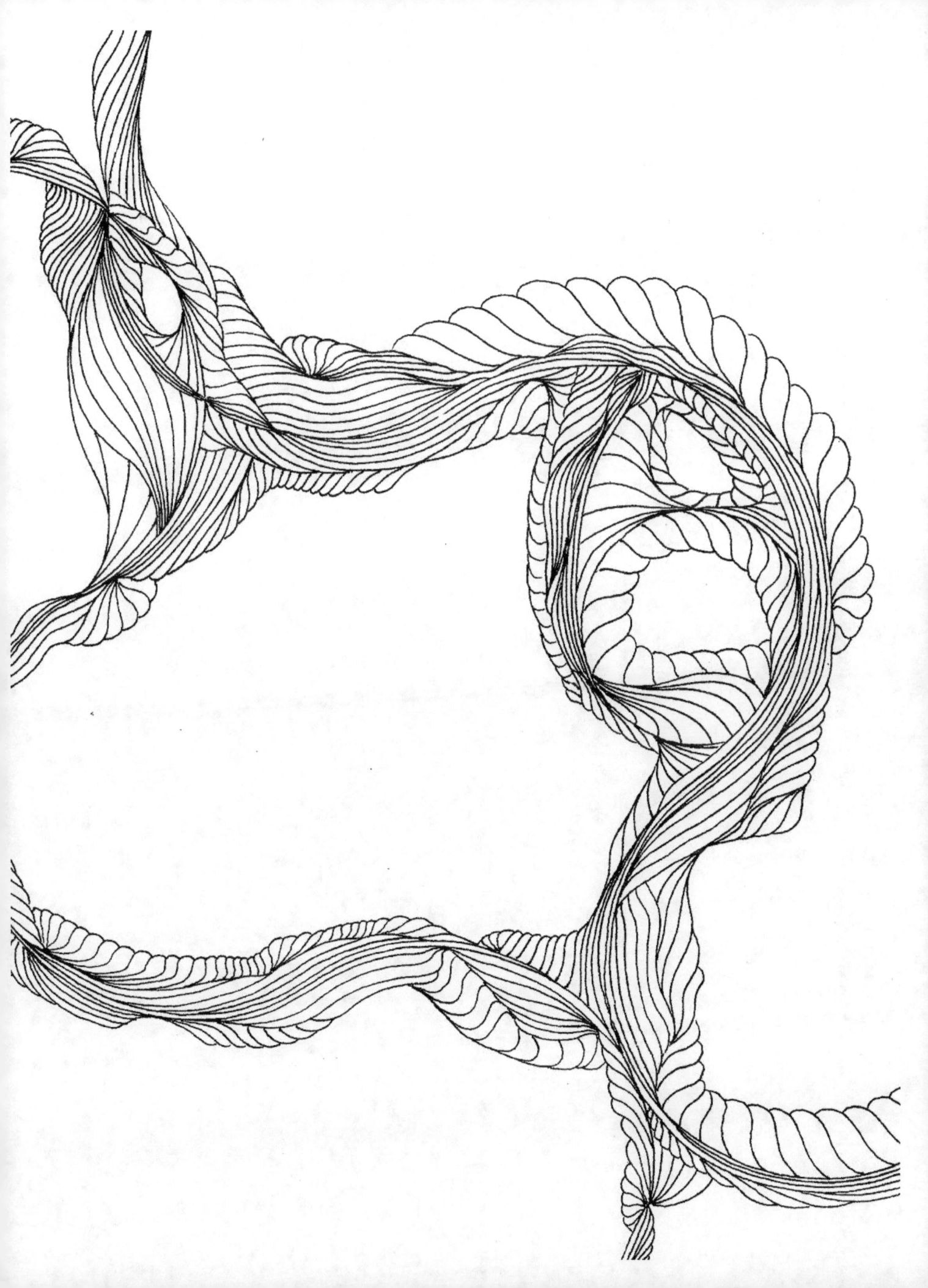

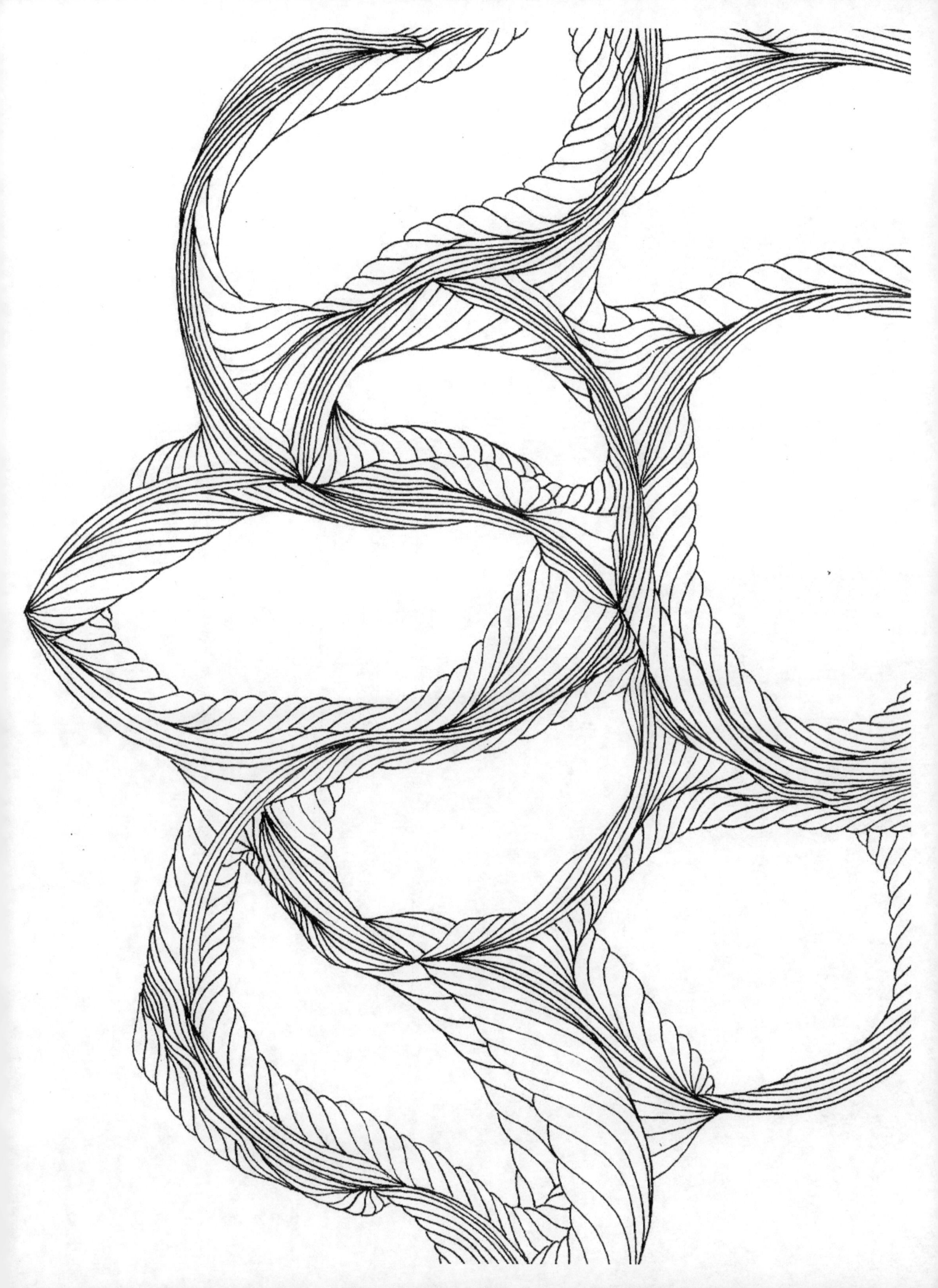

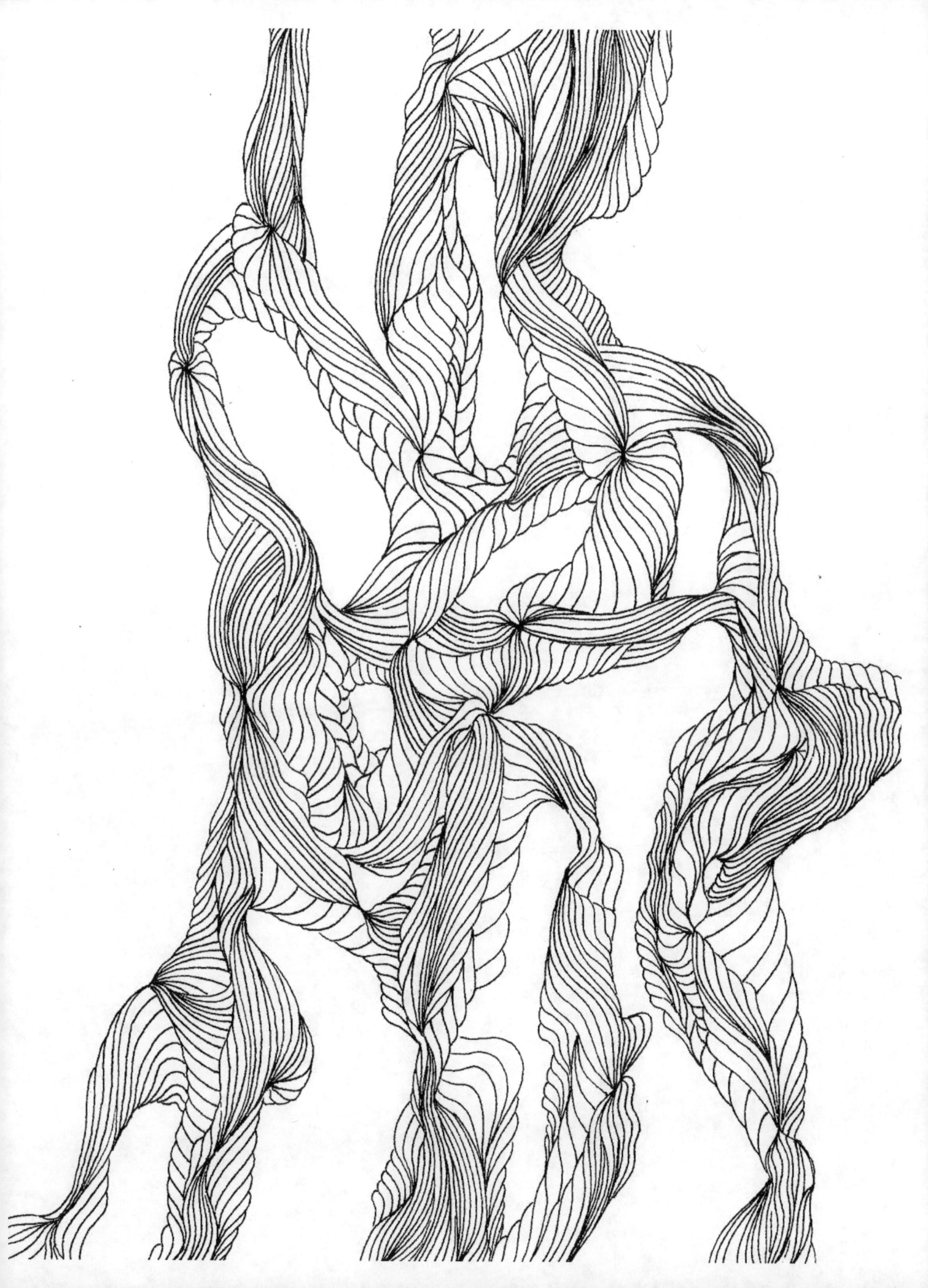

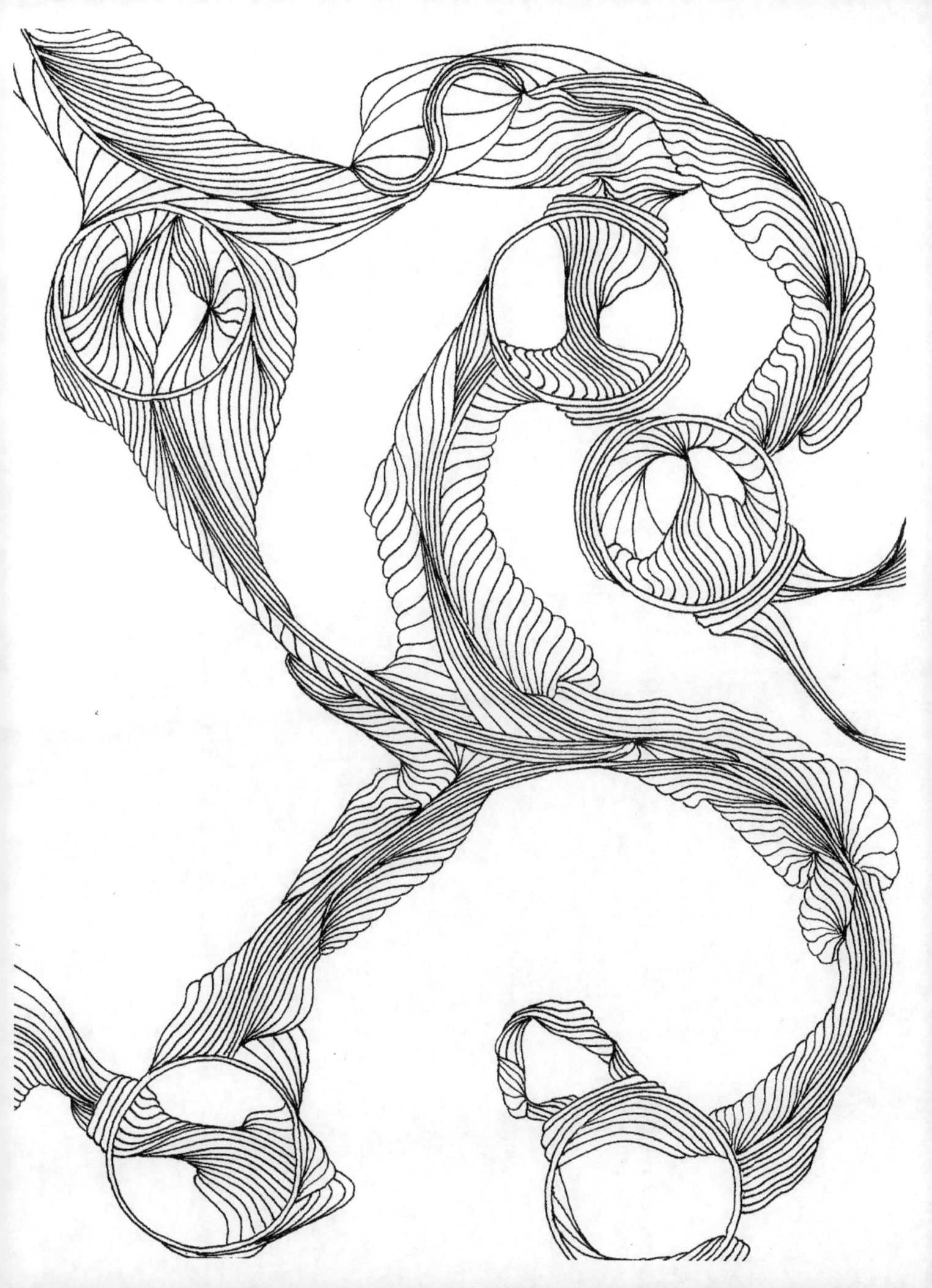

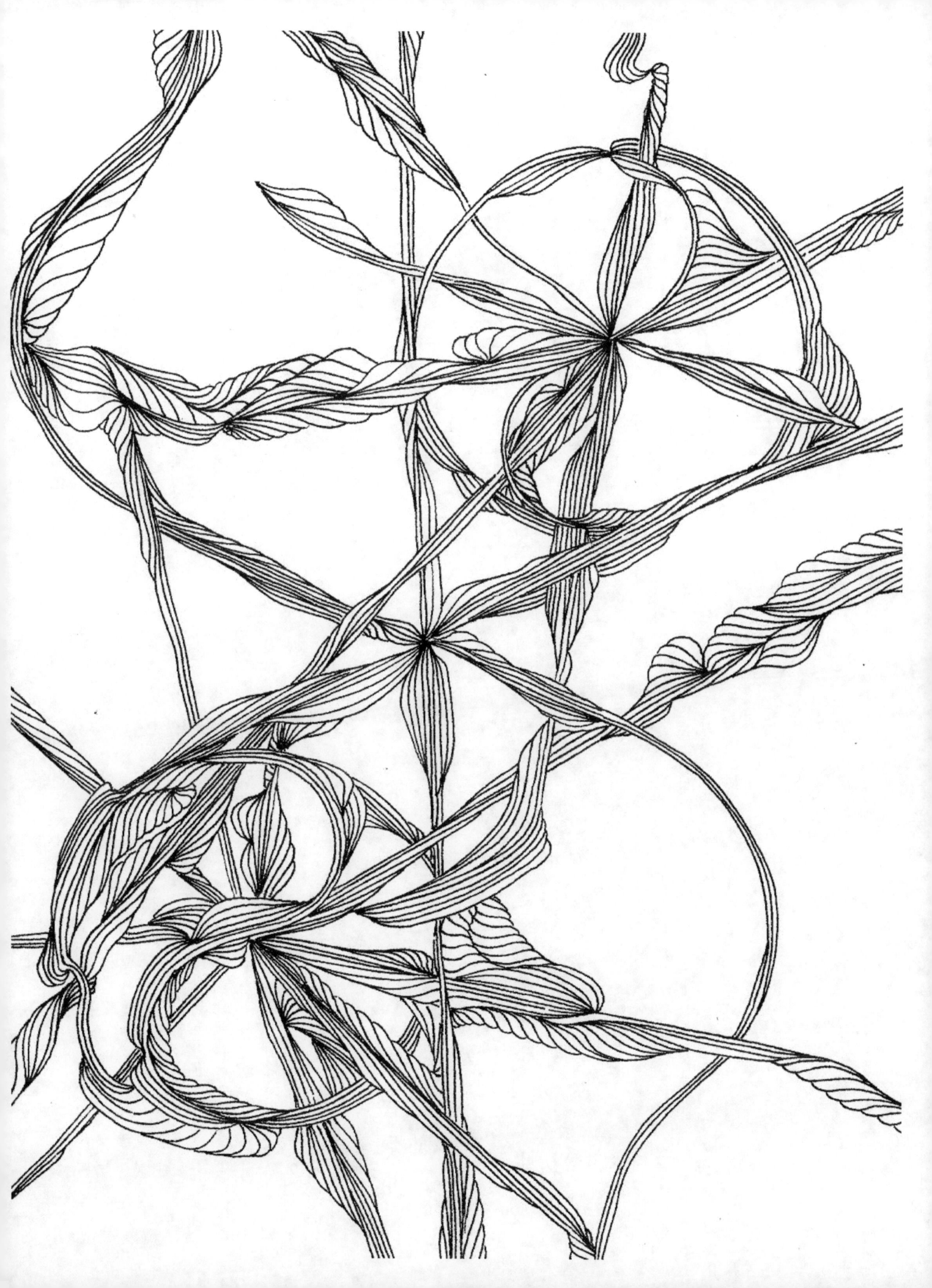

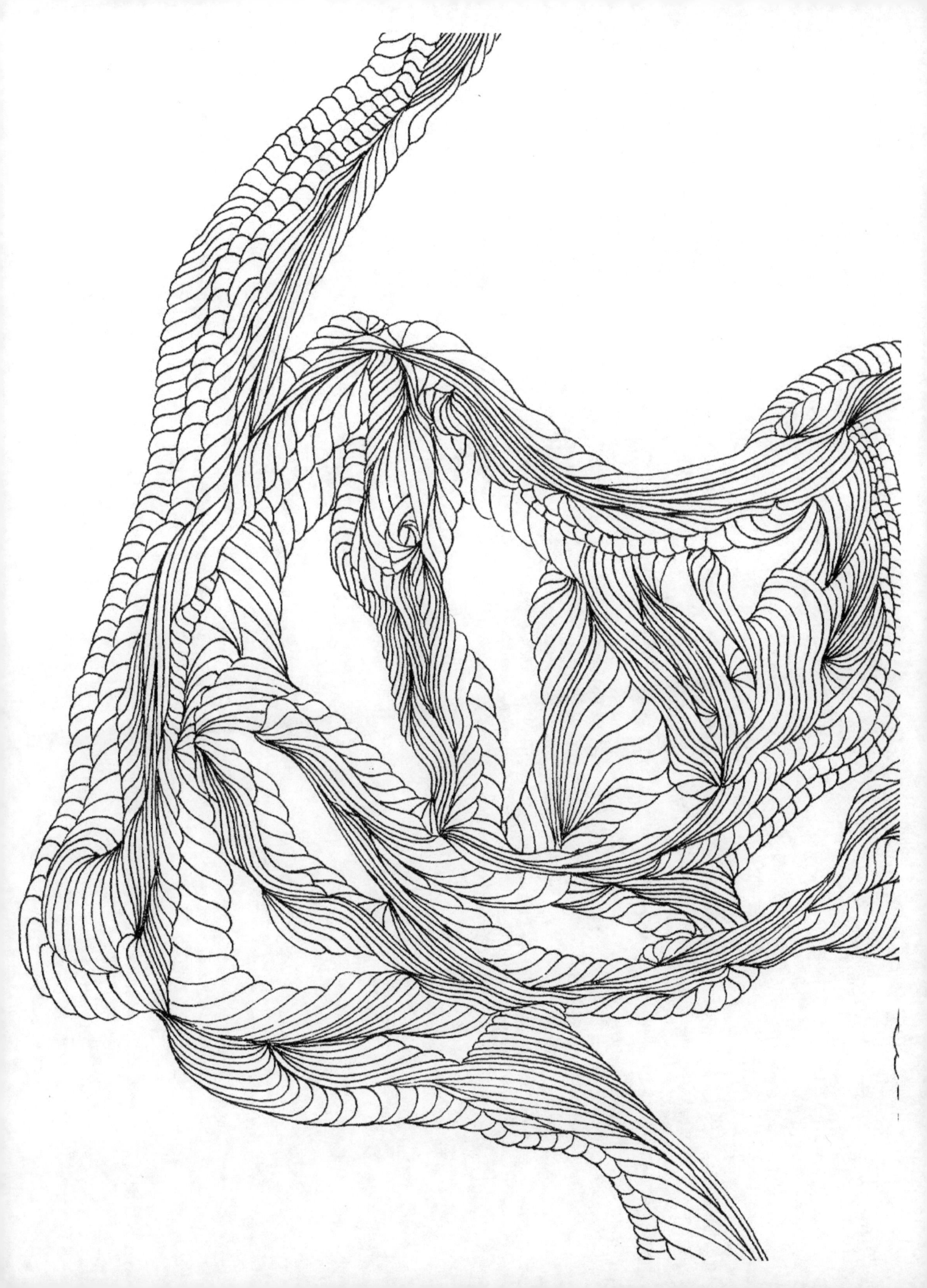

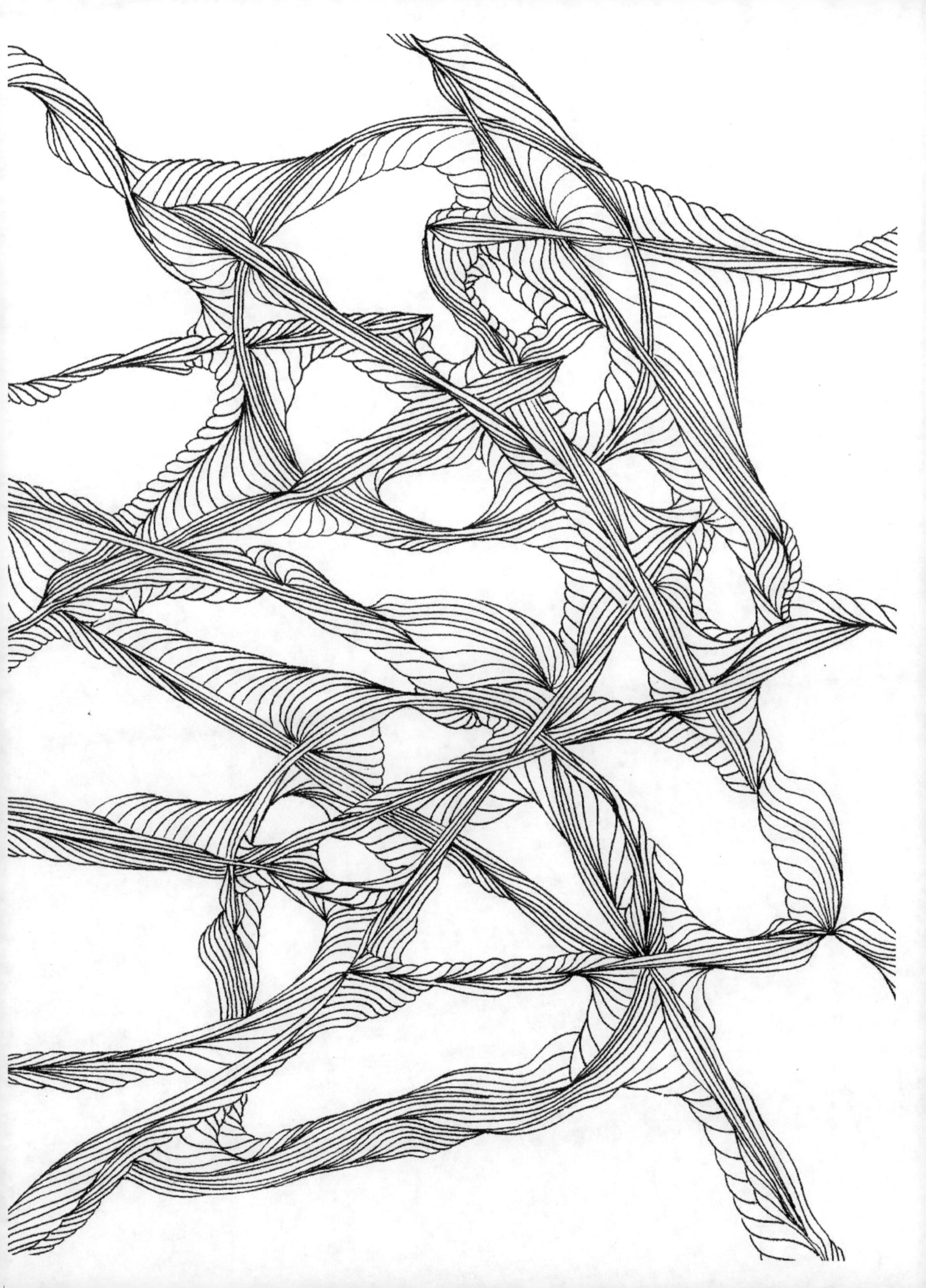

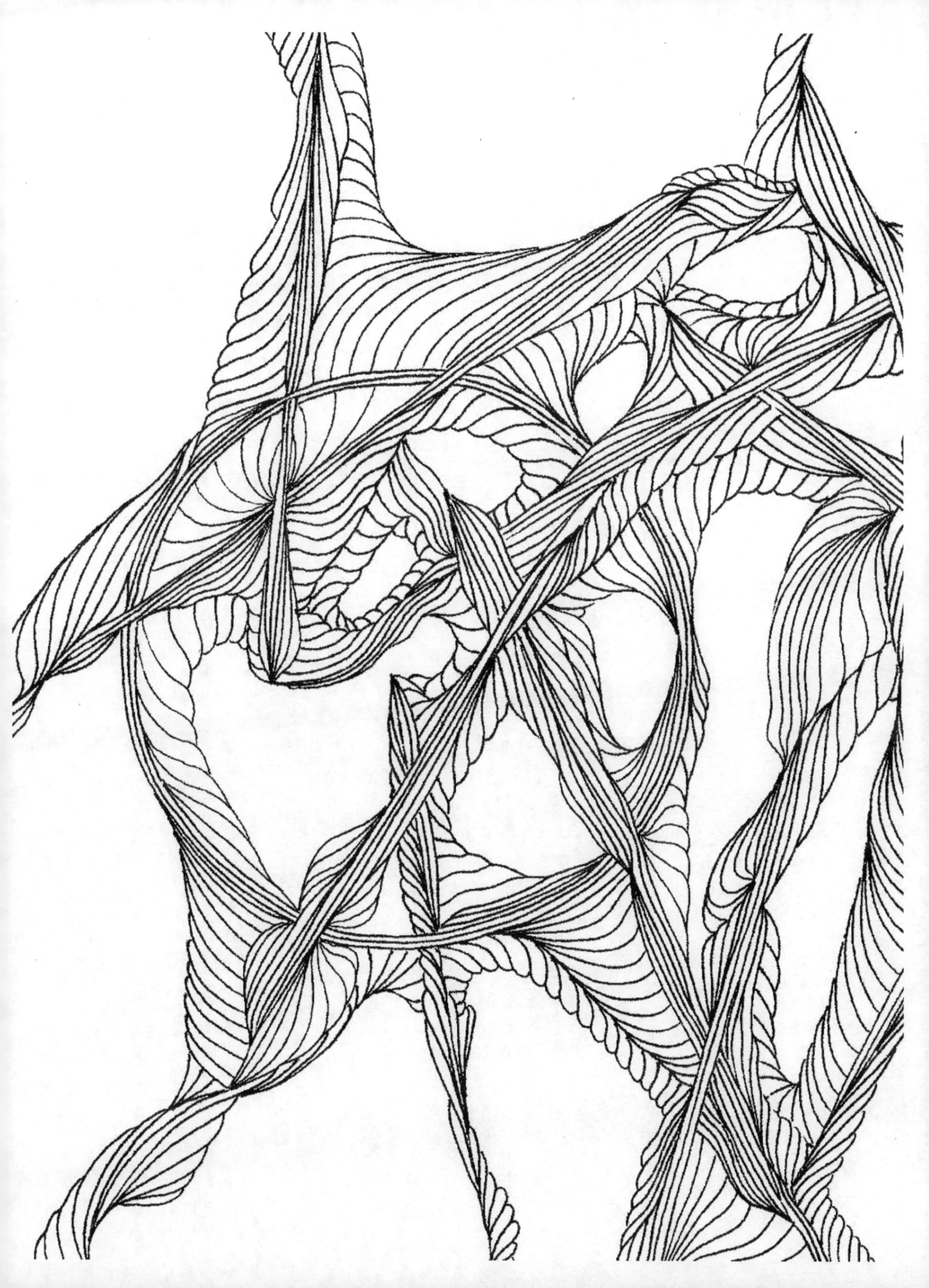

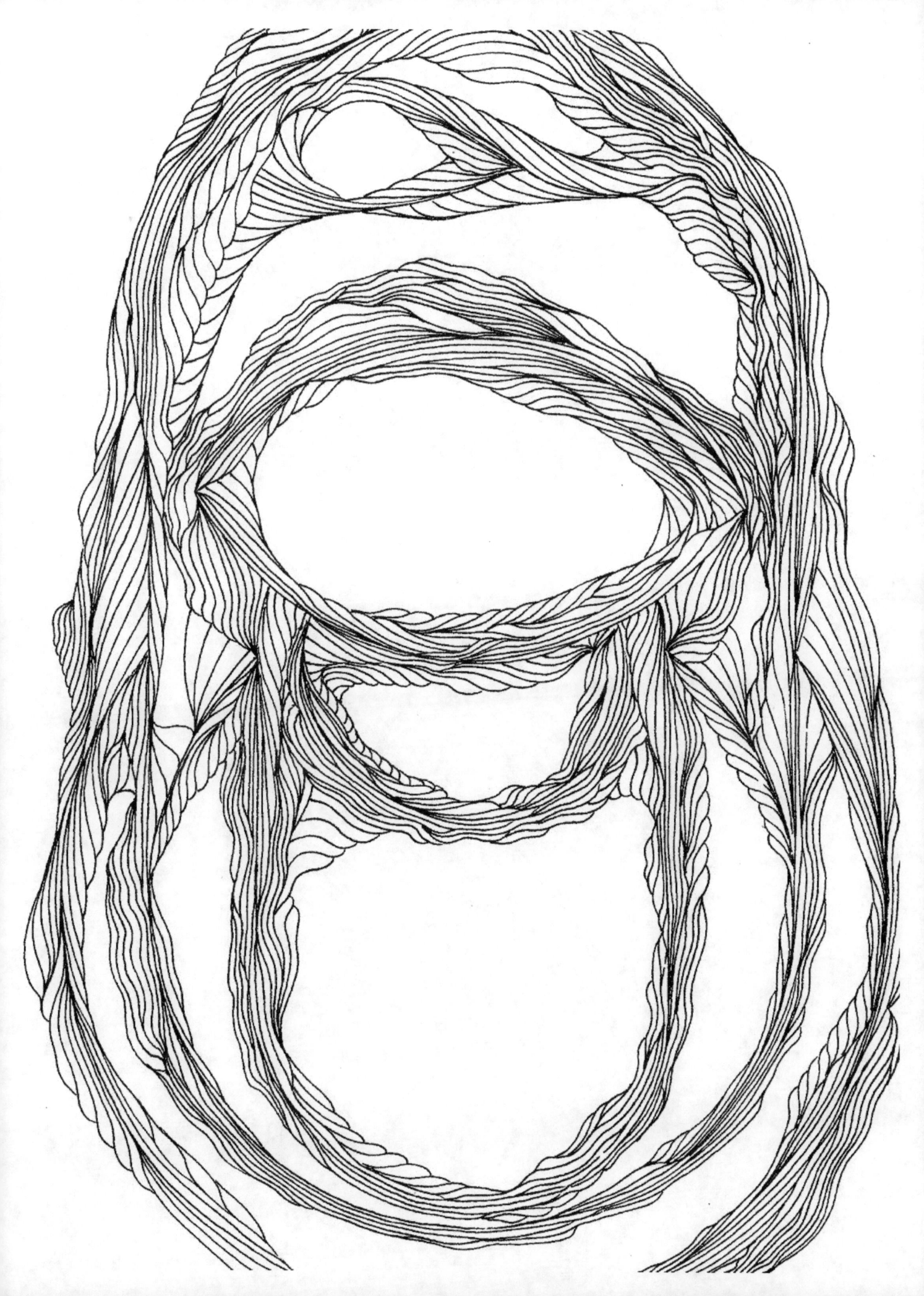

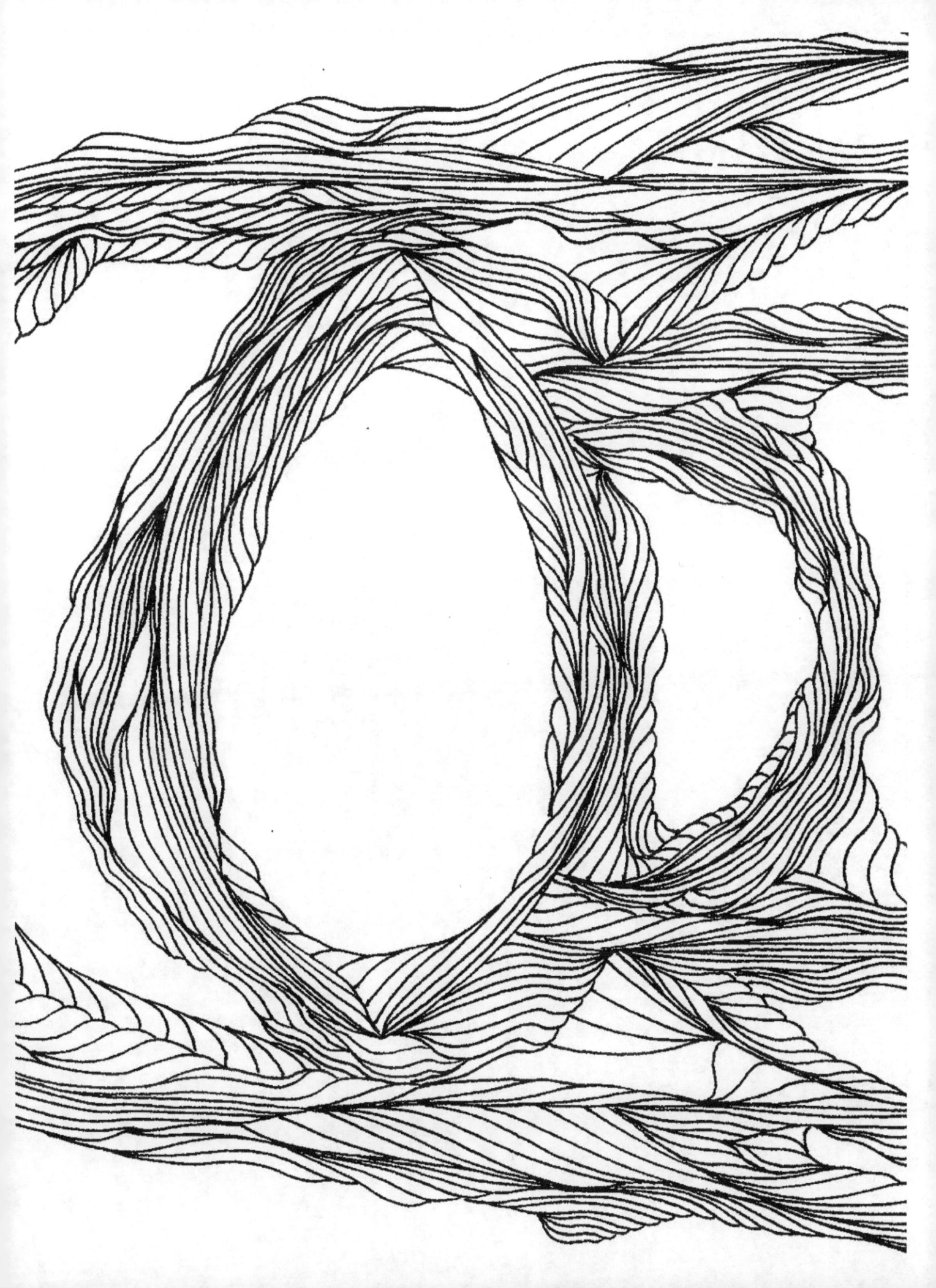

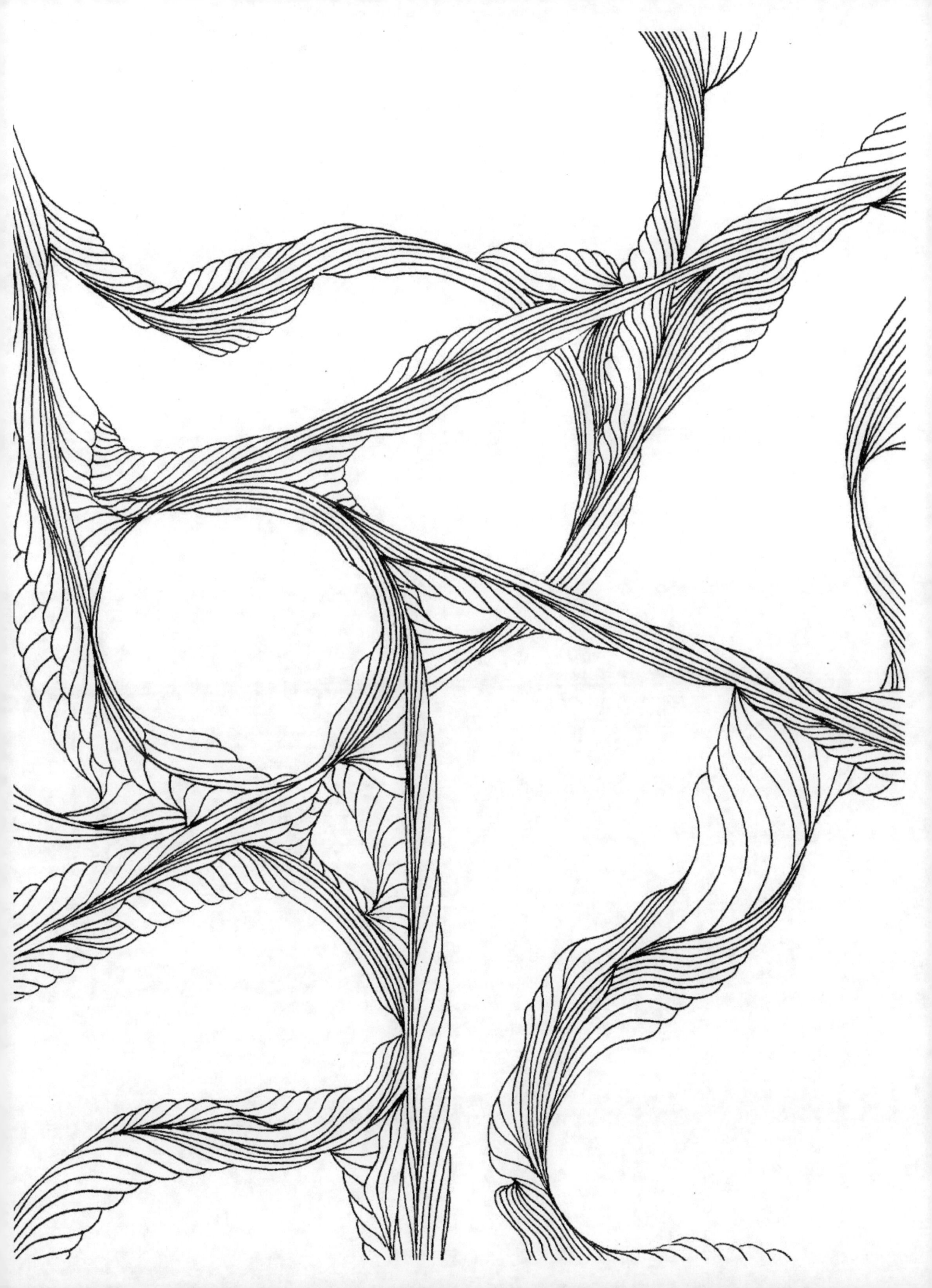

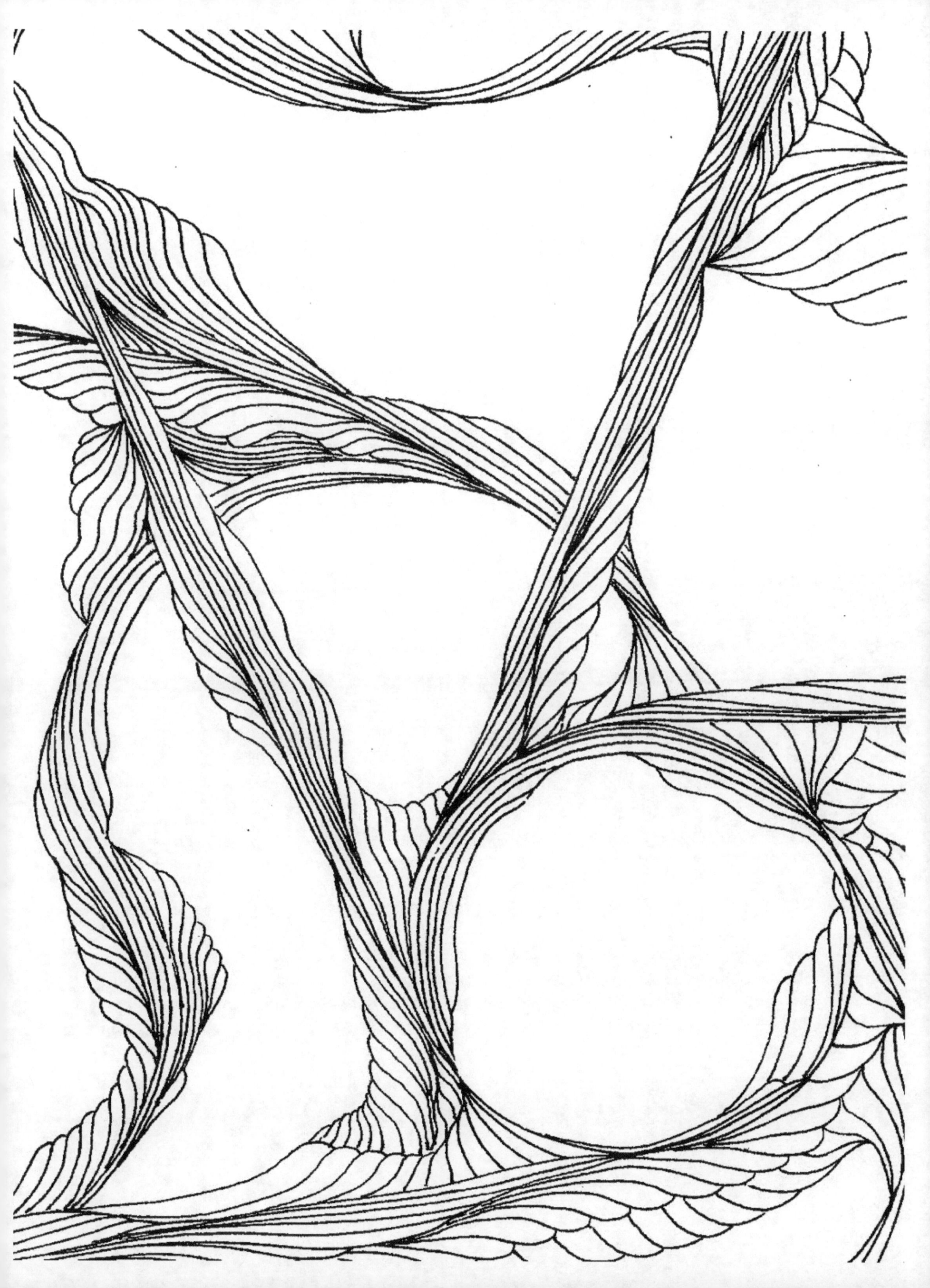

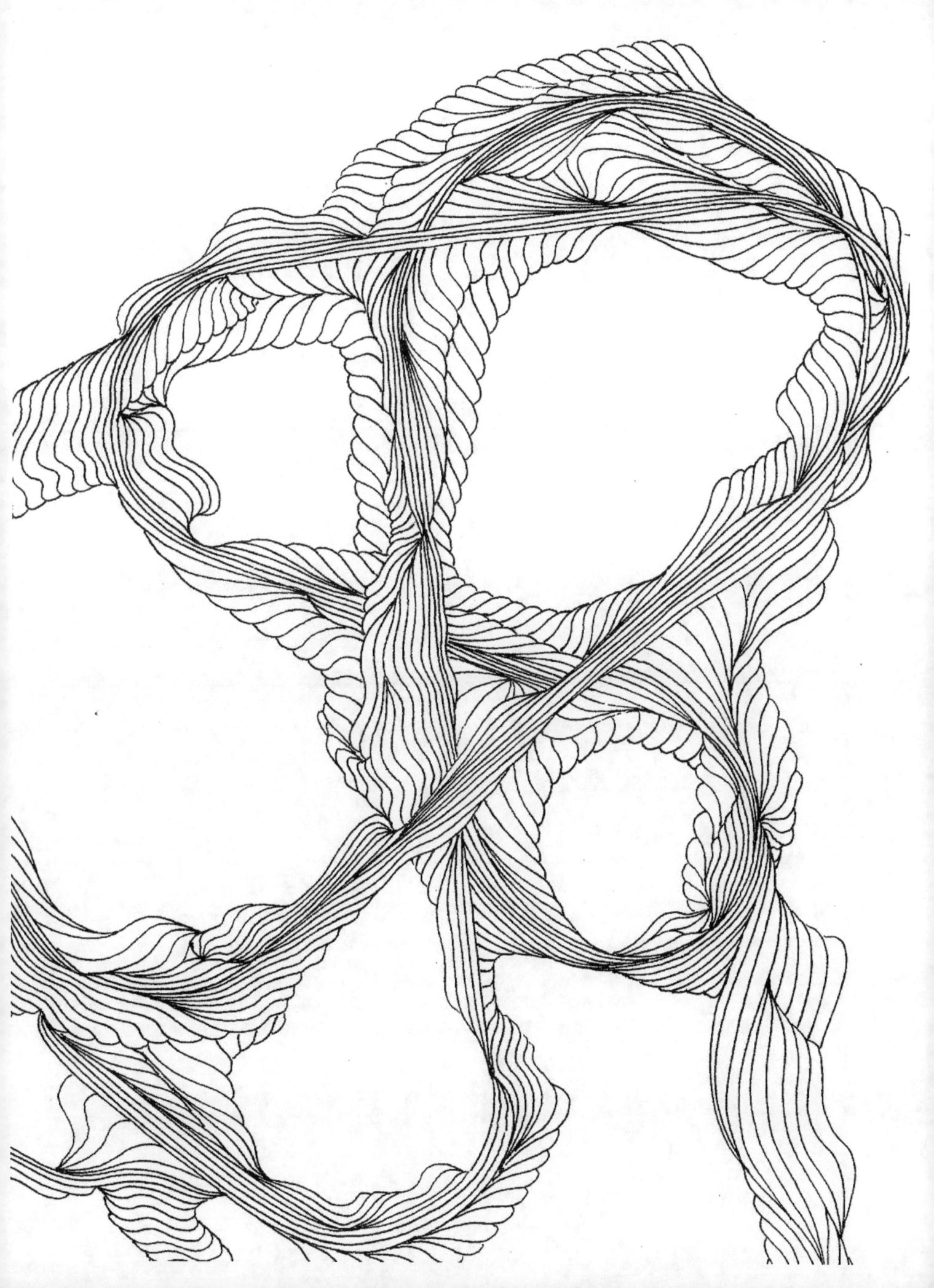

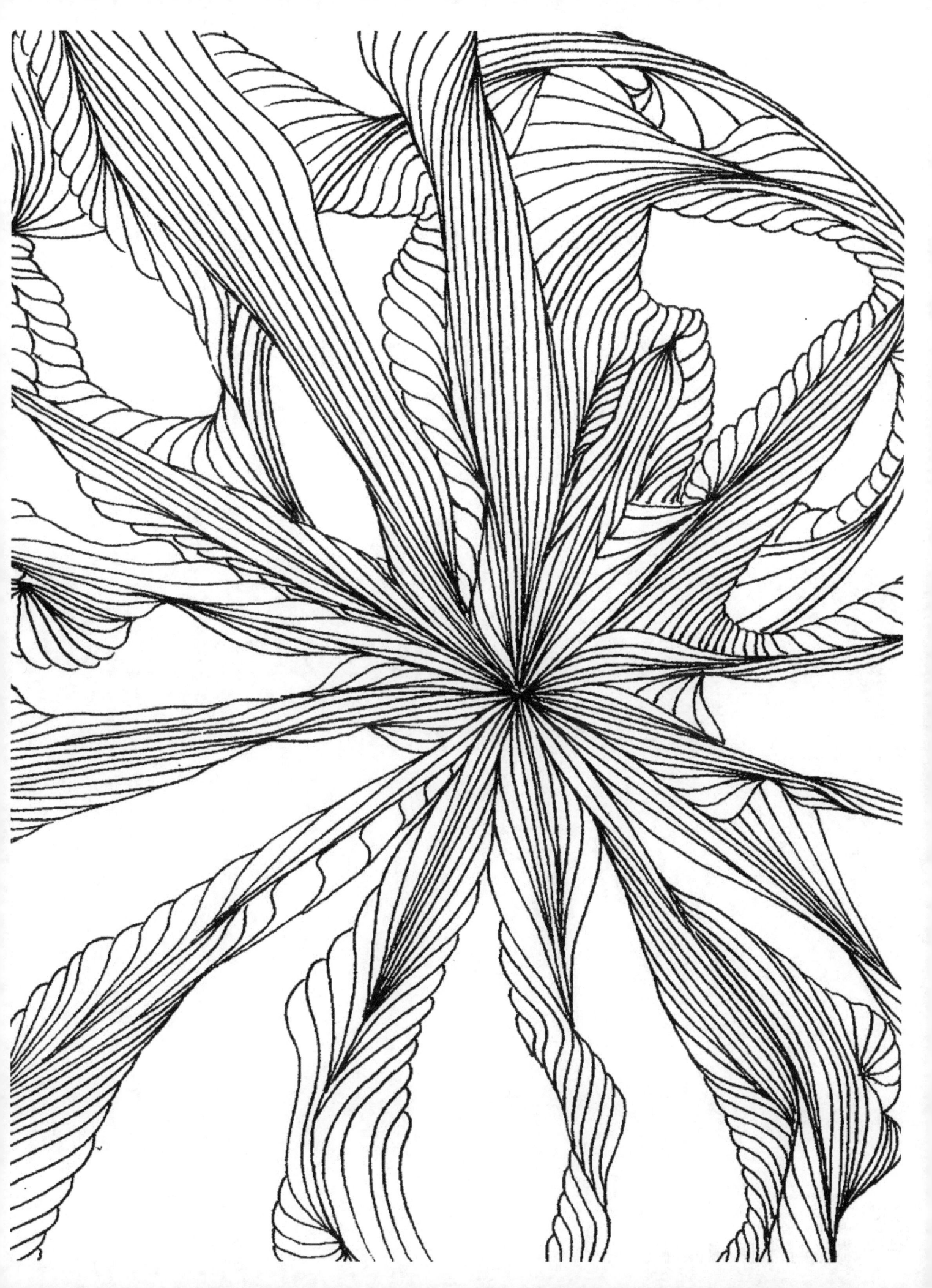

www.ingramcontent.com/pod-product-compliance
Lightning Source LLC
Chambersburg PA
CBHW080716190526
45169CB00006B/2401